LEEDS-BRADFORD AIRPORT
THROUGH TIME
Alan Phillips

AMBERLEY PUBLISHING

First published 2012

Amberley Publishing
The Hill, Stroud
Gloucestershire, GL5 4EP

www.amberley-books.com

Copyright © Alan Phillips , 2012

The right of Alan Phillips to be identified as the
Author of this work has been asserted in accordance
with the Copyrights, Designs and Patents Act 1988.

ISBN 978 1 4456 0609 5

British Library Cataloguing in Publication Data.
A catalogue record for this book is available from
the British Library.

Typeset in 9.5pt on 12pt Celeste.
Typesetting by Amberley Publishing.
Printed in the UK.

Contents

Acknowledgements

Grateful thanks are extended to the following for their valuable assistance and information.

Aer Lingus
Airfield Research Group
Airports Archives
Mr Ed Anderson (Former Airport Director)
British Aerospace Systems
British Airways
bmi – British Midland International
Dart Group PLC, Jet 2
Mr C. Dennison (Former Airport Director)
Eastern Airways
Flybe
KLM

Leeds Bradford International Airport
Leeds Libraries – Central Library
Leeds Archives
Manx2.com
Multiflight
Thomas Cook Airlines
TUI Travel PLC
RyanAir
Mr Clifford Walker
Mr Les Woad

Bradford Telegraph and *Argus*
Yorkshire Post

Special thanks to the airlines (most of which by today have ceased trading) that have operated from Leeds Bradford and who have supplied me with a vast amount of information.
 Also I would like to thank numerous individuals, past and present employees of the airport whom have provided me with valuable information and photographs.

CHAPTER 1

Searching for an Ideal Site

Yorkshire has always attracted the imagination and enthusiasm of individuals who foresaw a future in aviation, and perhaps if it had not been for these early aviators one might not have the present airport. Perhaps the first known Yorkshireman to be genuinely interested in aviation was the baronet Sir George Cayley of Brampton Hall during the early part of the nineteenth century. It is believed that he built a number of flying models in his private workshop. Several of his models and drawings can be seen at the Science Museum, London.

The next aviator to arouse the interest of the population was Col Samuel Franklin Cody, better known as Buffalo Bill, who in 1901 during a visit to Leeds demonstrated his war kites to government inspectors on Holbeck Moor, another of the sites surveyed in the twenties. When a heavier than air flying machine built by the Wright Brothers flew in Kitty Wake, South Carolina, in December 1903, the whole concept of flying changed. Soon aviators throughout Europe began to design and build their own flying machines. Great interest arose in Yorkshire with air pageants and demonstrations. Flying machines that dominated the scene were mostly French, like the Blériot monoplanes, Farman Biplane and the famous Cody's Cathedral.

It also gave rise to several home-bred aviators like the Bradford-born Richard 'Bobby' Allen, who built his own flying machine, and Robert Blackburn, who started the Blackburn Aircraft Company. From humble beginnings in a basement of a clothing factory he built his first monoplane, which he transported to Marske-by-the-Sea for test flying. Over the next few years Robert Blackburn continued to develop and improve his monoplane. In May 1914 the company was chosen to build the Farnborough-designed BE2C biplane for the Royal Flying Corps. As his factory was unable to cope with a large production line, Robert Blackburn moved to a new facility at Olympia Works on Roundhay Road, with its adjacent grass area for flight testing at nearby Soldier's Field. Another local aviator was Harold Blackburn of Carcroft, Doncaster, (no relation to Robert Blackburn), who during the Yorkshire Show held at York on the 23rd, 24th and 25th July 1913 delivered copies of the *Yorkshire Post* newspaper to the show ground some two hours after they came off the press in Leeds. In October he entered the Yorkshire and Lancashire Air Race, but perhaps his mast notable flight was on 22 July 1914 when he made one of the first recorded passenger flights in the United Kingdom, by flying the Lady Mayoress from Leeds to Bradford.

The first flying machine in Bradford was a Blériot Monoplane acquired by the Northern Aero Syndicate, who in 1910 chose Rawdon Meadows as a site for the Airedale Aerodrome, which

would be a permanent base for their monoplane and a centre for aviators in the north. Due to the lack of support and finance the plan was dropped and the Northern Aero Syndicate moved its monoplane to Filey, where it continued to fly until the syndicate was dissolved.

After the First World War interest in commercial flying re-kindled, a daily parcel service starting in June 1919 between Leeds, Soldiers Field and Scarborough. On 30 September 1919 a scheduled passenger service to Hounslow, London, began. It was operated by North Sea Aerial Navigation using two Blackburn Kangaroos, G-EAIT and G-EAKQ, which had been built by Blackburn at the nearby Olympia works. Due to a rail strike, North Sea Navigation operated mail flights between London and Newcastle with a stop at Leeds. Robert Blackburn continued to operate the landing site, which had been renamed Leeds Flying Field, until the company moved to a new site at Brough near Hull.

In the post-war period a number of towns and cities in the United Kingdom were in the process of planning and building municipal aerodromes for commercial use, and it was felt that the cities of Bradford and Leeds urgently needed a permanent site.

In the late twenties Sir Alan Cobham, a renowned aviator surveyor, was hired to survey the areas around Bradford and Leeds as the possible site for a landing field. Several sites were considered but none were regarded as a permanent site that could be developed. Sites surveyed were mostly First World War landing grounds located on the outskirts of the cities.

The most obvious site was what locals referred to as Soldier's Field at Roundhay Park, adjacent to Robert Blackburn's aircraft factory at Olympia Works. The site was highly recommended by Alan Cobham during his aerial survey, but the extent of the site was limited as it meant occupying public park land. During the First World War the City of Leeds was allocated three landing sites on its outskirts, namely Farsley, Middleton and Seacroft. All the sites was classed as primitive as they consisted of a landing area, some tented accommodation and no hangars. These landing grounds were operational from March to October 1916; by then the threat of air raids had ceased.

The Farsley site was just a grass strip situated to the west of the village of the same name, running north of what is known today as Dawson Corner. Part of the site is occupied today by the Leeds Ring Road. In the late twenties the site was put forward as a possible site for a new municipal aerodrome, but lost out to Yeadon.

Middleton, south of Leeds, was another landing ground used by the RFC, but mostly as a night landing area due to the flatness of the area. After the departure of the military the site was abandoned except for a brief period towards the end of the war, when it was used for parachute training from stationary balloons.

The last of the Leeds landing areas was at Seacroft, covering the eastern section of the city. It was the largest of the three sites but again with no permanent facilities. Neither area was ever considered as a site for a permanent municipal aerodrome.

Other landing fields were situated on the outer perimeter of the cities of Bradford and Leeds. Dunkeswell was situated on the north side of Leeds, between the city and Harrogate. The landing area consisted of a forty-acre grass area, again with no permanent buildings, and remained operational from March to October 1916. The area was surveyed by Alan Cobham twice in the twenties.

The other field was at Cullingworth, or Manywell Heights as it was more commonly known. The landing ground was situated just south of the village of Cullingworth, south of Keighley

and west of Bradford. It was one of the largest First World War landing grounds and was operational from 1916–19. Due to its location, it was not regarded as an ideal location either for a permanent airfield or a municipal aerodrome. In 1919, the site was used briefly for mail flights between Hounslow and Doncaster.

Some twelve miles north of Leeds is the airfield at Sherburn. It originated during the First World War and consisted of a grass landing area with few permanent wooden buildings and several wooden and canvas hangars. During the war it became an acceptance park for the Royal Flying Corps and later the RAF. By 1918, the airfield covered an area of 177 acres, with permanent brick-built accommodation, eight hangars and twenty-one corrugated storage sheds.

By the late twenties, the majority of First World War sites were regarded as not suitable for development as new housing estates had been built nearby, restricting any possible future extensions to the aerodrome.

From the outset Yeadon aerodrome was planned for commercial flying with ample space for expansion. In all, thirty-five acres were acquired for an all-round landing strip and associated buildings. Four steel and asbestos hangars were built, two just off the Harrogate Road and two adjacent to White House Lane. Even then some councillors doubted their decisions, as the area needed considerable work done to level the ground and install proper drainage. Being situated on a hill the area was also prone to bad weather, which continued to plague the airport.

Therefore, over the last eighty years or so the airport has grown from a grassy uneven landing ground to an ultra modern international airport. With proper investment and support from its owners, the councillors and local inhabitants, the airport will have a beneficial future.

Mechanics' Magazine,

MUSEUM, REGISTER, JOURNAL, AND GAZETTE.

No. 1520.] SATURDAY, SEPTEMBER 25, 1852. [Price 3*d*., Stamped 4*d*.

Edited by J. C. Robertson, 166, Fleet-street.

SIR GEORGE CAYLEY'S GOVERNABLE PARACHUTES.

Fig. 2.

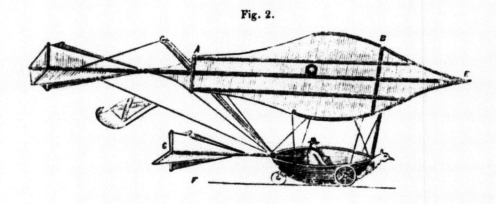

Fig. 1.

Drawing of George Caley's flying machine. (via Science Museum, London)

S. F. Cody's kite flew on Holbeck Moor in 1901.

A series of Samuel Cody's kites with the man himself at an exhibition in London.

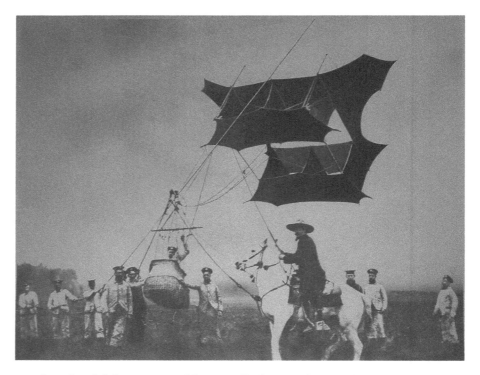

Another of Cody's kites. He would eventually die in a plane crash in 1913.

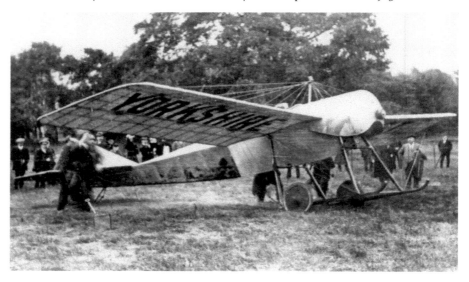

Early Robert Blackburn monoplane at Soldier's Field, Roundhay, 1913.

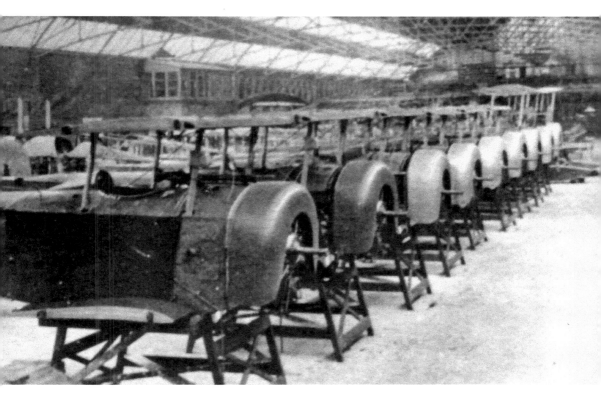

Blackburn Aircraft factory at Olympia Works.

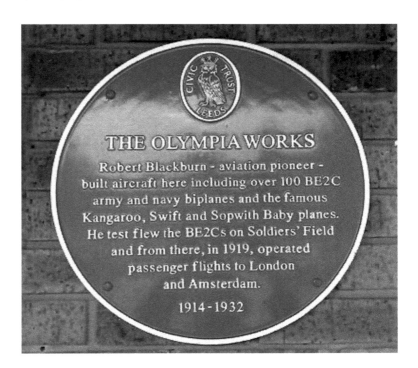

Plaque
commemorating
Blackburn's aircraft
factory at Olympia
Works.

CIVIC TRUST
LEEDS

THE OLYMPIA WORKS

Robert Blackburn - aviation pioneer -
built aircraft here including over 100 BE2C
army and navy biplanes and the famous
Kangaroo, Swift and Sopwith Baby planes.
He test flew the BE2Cs on Soldiers' Field
and from there, in 1919, operated
passenger flights to London
and Amsterdam.

1914-1932

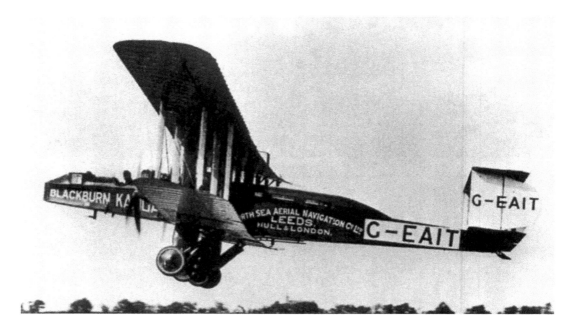

Blackburn Kangaroos were built at Olympia Works. Two were acquired by North Sea Aerial Navigation Company for services between Roundhay Park, Leeds and London.

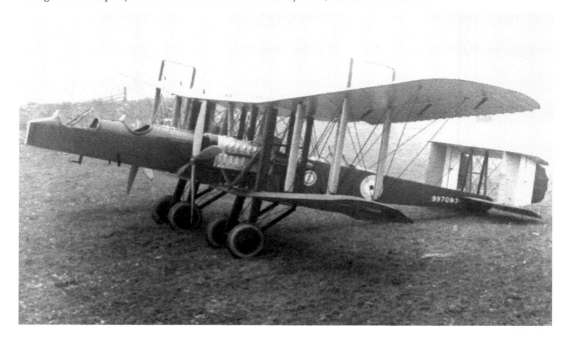

An RAF Blackburn Kangaroo.

CHAPTER 2

Yeadon Early Days 1931–39

By the early 1930s, the majority of towns and cities throughout the United Kingdom were either in the process of building or drawing up plans for municipal aerodromes. Therefore, it was felt that cities of Leeds and Bradford needed a permanent site for a civil aerodrome. Up to then nearly all flying had been from Soldiers Field, Roundhay Park. But as Blackburn had more or less completely moved out of Olympia Works, flying from the park had been drastically reduced. Anyhow, this site was not really considered suitable for any further development and the area was returned to public use. Today this part of the park is used as sport playing fields for the surrounding area.

The First World War sites were not serious contenders as there were restricted in their potential future development. As it was such an important decision with both cities involved, it was decided to obtain the expert advice of the famous aviator and air surveyor, Sir Alan Cobham. All suitable areas ideally not more than five miles from both cities were surveyed from the air and on the ground. Sir Alan came to the conclusion that the best site for an aerodrome with a potential for future development was at Whinmoor. This was situated on a plateau and had clear approaches on all sides, which were needed for safe operations.

The Farsley site was considered too restricted for any expansion as it was too near the village of Farsley as well as being surrounded by hills, which would restrict approach and take off. At the time, the partly moorland and grassy field site near Yeadon was also not regarded as an ideal location, as there were too many drawbacks including its altitude, proximity to high ground and considerable work needed to level the land and for drainage. After several council meetings, it was finally decided to more or less ignore Sir Alan Cobham's report and choose the Yeadon site as it was more or less the same distance from Leeds and Bradford. Some councillors at the time were outraged that the council had paid a substantial fee to Sir Alan Cobham for a survey, which was totally ignored.

The Yeadon site consisted of grassy fields and moorland, just off what is now the A658 Leeds to Harrogate road. The nearest houses at the time were over half a mile away on the Bradford to Harrogate road, so there were would be no complaints from local residents. In 1931, an area of some sixty acres was established, comprising a landing area of approximately 300 feet by 2,100 feet, which at the time was quite adequate for the operation of most type of aircraft in use. The Lord Mayors of Leeds and Bradford officially opened the new aerodrome on 17 October 1931.

By October 1931, the Yorkshire Aeroplane Club had completely moved from Sherburn-in-Elmet airfield to their new premises at Yeadon aerodrome. As the club had considerable experience in general aviation, it was asked to operate the new airport on behalf of the Joint Airport Committee which had been created by Leeds and Bradford Councils to oversee the new venture. The earliest aircraft to use the aerodrome were various club types like the Cirrus Moths, the Gipsy Moth, and later the Puss and Leopard Moths, and of course the renowned Tiger Moth, all from the de Havilland stable. The club also provided aircraft for the official opening service on 17 October.

The Yorkshire Aeroplane Club's chief instructor and co-founder was the energetic and popular Captain H. V. Worrall, DSC, who, during the war, was involved in destroying the German battleship *Goeben*, which was grounded in the Dardanelles. For a brief period after the war Captain Worrall became a test pilot for the Blackburn Aircraft Company at Brough. In 1927, he joined Alan Cobham on one of his surveying trips around Africa, and eventually in January 1928 joined the Yorkshire Aero Club.

In June 1932 Alan Cobham made a return visit to Yeadon with his famous flying circus. During the visit, as well as thrilling the crowd with an exciting flying display, he offered pleasure flights at five shillings a time in an Airspeed Ferry aircraft. Other aircraft involved in the display were an Avro 504 and the largest aircraft then to land at the aerodrome, a Handley Page W10.

Although the Yeadon site was not the recommended location given by Sir Alan Cobham to the council in 1929, he was nevertheless impressed by what had been achieved so far in the few years since he had surveyed the area. Seeing the potential of development, he arranged for one of Imperial Airways' commercial airliners, G-EBBI *Prince Henry*, to visit the aerodrome, which attracted onlookers from afar.

From the outset the aerodrome was planned for commercial flying, with ample space for expansion. During the first few years, however, most of the flying from the aerodrome had been for pleasure and club flying. It was not until 1935 that the first commercial service was introduced. That honour went to North Eastern Airways, which inaugurated the London to Edinburgh service, with stops at Yeadon and Newcastle, using two brand new Airspeed Envoys; the first flight took place on 8 April 1935. The inaugural flight was organised so that both the southbound and the northbound aircraft met at Yeadon, where a large crowd had gathered, including many prominent people from various parts of the West Riding. Just before the final leg of their flights, the Envoys were named *Wharfedale* (G-ADBB) and *Tynedale* (G-ADAZ) by Mrs Eden on behalf of her husband Mr Anthony Eden, the Lord Privy Seal, who was indisposed at the time. Mrs Eden smashed a bottle of wine on the nose of each airliner and wished God speed to the aircraft and all who travelled in them.

Passengers on the London flight were Lord Grimethorpe, Chairman of North Eastern Airways, Mrs Eden, the Lord Mayor and Lady Mayoress of Leeds – Alderman and Mrs W. Hemingway – Alderman F. H. O'Donnell, the Deputy Chairman of the Airport Committee, Major Cameron, Colonel W. Boyle and members of the press. On the northbound flight to Newcastle and Edinburgh were Admiral Sir Cyril Fuller, Mr R. H. S. Somerset, Managing Director of the airline, and Mr C. Fullergill, a *Telegraph* and *Argus* reporter.

Total flight time between London and Edinburgh was 2 hours and 45 minutes. The air fare between the two cities was a mere £10, which worked out at 6d (old pence) per mile. Lord Grimethorpe proudly announced in his speech that the first aim of the airline was reliability, second punctuality and third bravery and determination, meaning that the aircraft would fly in all weather.

The Envoy, built by Airspeed Aircraft Company at Portsmouth, was a six–eight seat development of the smaller AS5 Courier and first flew on 26th June 1934. It was powered by two 315hp Armstrong Whitworth Cheetah VI engines, which gave it a top speed of 210 mph and a cruising speed of 170–180 mph. North Eastern Airways ordered three aircraft; the third, G-ADAZ *Swaledale,* was delivered a month later.

During the first month of operations, nearly six hundred passengers had flown, but after the initial success passenger numbers declined so much that the service was terminated. A very sad ending to an enterprising endeavour, but at least it was a beginning to scheduled services from the aerodrome.

These early flights were not with incidents. On its inaugural flight, the southbound Envoy G-ADAZ, carrying a party of dignitaries, overshot a landing at Heston and ran into the boundary fence. Fortunately there were no casualties and damage to the aircraft was superficial. Another mishap occurred in May when Envoy G-ADBZ *Swaledale,* just after taking off from Yeadon, developed carburettor trouble near Ripon, resulting in an emergency landing in a cornfield. Once again no one was injured and the aircraft was made airworthy in a short time.

Also in 1935, Yeadon experienced its first fatal accident, when on 23 March a Miss Mary Clark of Leeds, a passenger in a Tiger Moth, was killed when the aircraft struck telephone lines during an approach to the aerodrome. Miraculously, the pilot escaped with minor injuries.

Seeing the potential of Yeadon as a gateway to the West Riding of Yorkshire, Blackpool & West Coast Air Service began a seasonal Blackpool to Yeadon service in June using either a De Havilland DH84 Dragon or a DH89 Rapide. Passenger response was very encouraging on the route, which in 1936 drew the attention of the Railway Air Service. The airline's DH Dragon Rapide, one being appropriately named the *Star of Yorkshire* (G-AEAL), provided daily flights in both directions between Yeadon and Manchester (Barton Aerodrome), with connecting flights to the Isle of Man.

In the summer of 1936 Blackpool & West Coast Air Service was absorbed into the ever-growing Railway Air Service, which took over all the airline's routes including the Leeds–Blackpool schedule. Before the end of the year the Manx Airways division of the Railway Air Service took over all scheduled flights from Yeadon. By now, the service was extended to Blackpool and the Isle of Man via Liverpool (Speke) on the morning's westbound flight.

Load factors on these summer schedules was quite high, so much so that on a number of occasions, especially around holiday periods, a ten-seat DH86A Diane class was used. The service only lasted a few seasons, but it was the beginning of the Railway Air Service association with Yeadon, which lasted until the outbreak of the Second World War.

Within a mere five years Yeadon Aerodrome had made its mark on civil aviation in the north. Passenger traffic had increased twofold while aircraft movement had trebled, and future

prospects looked good. In 1936 the aerodrome consisted of the usual grass-covered surface with four landing areas: a north-south strip of 750 yards, north-east-south-west strip of 800 yards, east–west strip of 1,000 yards and a south-east–north-west strip of 750 yards. There were four hangars available, which were used for maintenance and storage. Just off the Harrogate Road stood the club house and administration offices. Due to an increase in traffic and the introduction of a scheduled air service, the aerodrome was upgraded with a short-range radio transmitter in October 1936. This enabled an aircraft to have radio contact with the ground during landing and taking off; up until then, pilots took off or landed when they wanted.

During the 1937 season, the Railway Air Service continued to operate the Blackpool and Isle of Man service, which continued to be very popular, but no other new routes were added. Meanwhile, membership of the Yorkshire Aero Club continued to grow under the energetic leadership of its manager Captain H. V. Worrall. This was despite the fact that membership fees for a flying member had increased to £3 3s entrance fee plus a £3 3s annual subscription. Although the increase was substantial in 1930s terms, it did not deter any new members and the club went from strength to strength.

Also in 1937, Air Taxi Service was formed at Yeadon. This new venture gave local businessmen and flying enthusiasts an opportunity to fly almost anywhere in the country. Flights in a DH Leopard Moth cost 4d per mile per person, while it was only 3d per mile per person in the more comfortable twin engine Short Scion.

Due to an increase in traffic and rising operating costs, the airport management decided to increase the landing fees to one shilling for aircraft weighing up to 1,500 lb and three shillings for aircraft between 3,600 and 4,500 lb.

Although Manx Airways had ceased operations in 1937, the air service to the Isle of Man was taken over by the Isle of Man Railway Air Service, which was a subsidiary of the Railway Air Service.

On 6 September 1938, the Air Navigation (Licensing of Public Transport) order was passed, which meant that all airlines had to apply for licences to operate any air services from British airports as well as on other routes. This was the forerunner of the present licensing system. However, licences for Yeadon were only applied for by two airlines, namely the Isle of Man Railway Air Service and North Eastern Airways.

The total number of passengers handled by the airport in 1938 was a modest 1,552 but nevertheless quite encouraging.

Since 1919 carrying mail by aircraft had grown considerably, especially so in the late twenties and the thirties as Imperial Airways expanded its route network in the world. North Eastern Airways was awarded a contract by the Post Office to carry mail from Perth in Scotland to London, with pickup points at Newcastle, Yeadon and Doncaster. The first mail flight took place on 3 October 1938. The service started at Perth using a DH Rapide but due to high winds an Airspeed Envoy (G-ADAX, *Tynedale*) piloted by F/O Gill continued the rest of the journey, picking up mail and passengers at Yeadon and Doncaster. The air mail service continued until 15 April 1939, when Yeadon and Doncaster were dropped from the schedule. Also, it was the end of the North Eastern association with Yeadon. Leeds and Bradford lost their air connection with both London and the north. Services to the Isle of Man continued throughout the summer

months with the local Air Taxi filling in the gap left by North Eastern Airways where possible. With a general unrest throughout Europe and the threat of war inevitable once again, airlines became more cautious and passenger traffic dropped, especially on flights to the continent. Everyone seemed to be waiting for that fateful announcement.

On 3 September 1939, the Air Navigation (Restriction in Time of War) became law, although initially only prohibited civil flying in the east of England and east of Scotland, but civil flying in the Leeds–Bradford area fell drastically. By September the Isle of Man service had ceased and did not resume again for another eight years. Yeadon was left with the Air Taxi and the Yorkshire Aero Club, whose activities had been reduced.

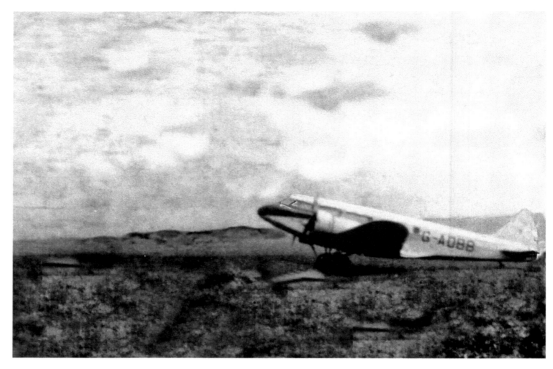

North Eastern Airspeed Envoy G-ADBB on its inaugural flight. This poor-quality image is the only one known of the aircraft at Yeadon.

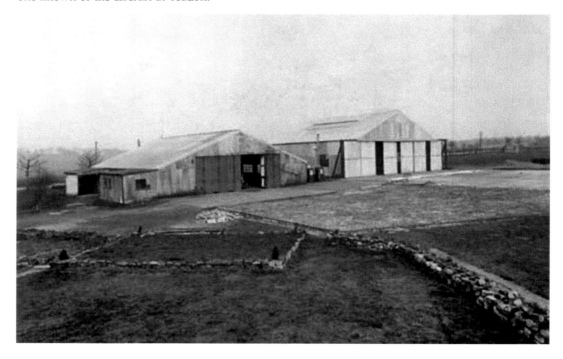

Two hangers were built by the Yorkshire Aero Club in March 1935.

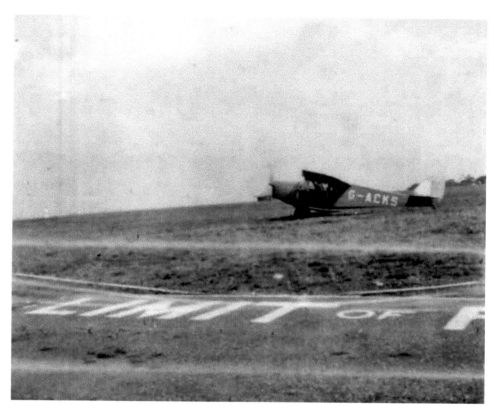

A Percival Gull taxiing over a rough part of the aerodrome, 1932.

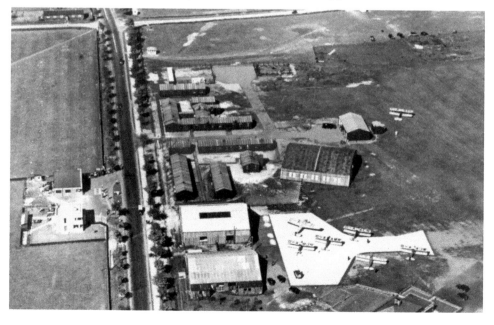

Aerial view of Yeadon, 1937. (C. H. Woods)

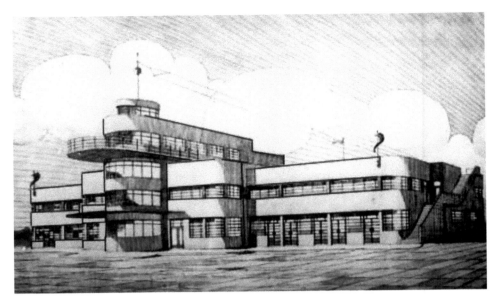

A 1936 artist's impression of the proposed terminal at Yeadon. This was never built. (via C. Walker)

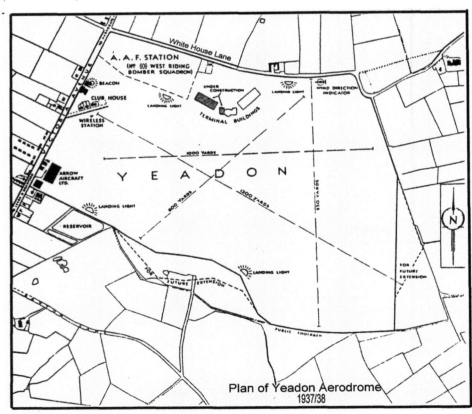

Layout plan for the airport, 1937/38.

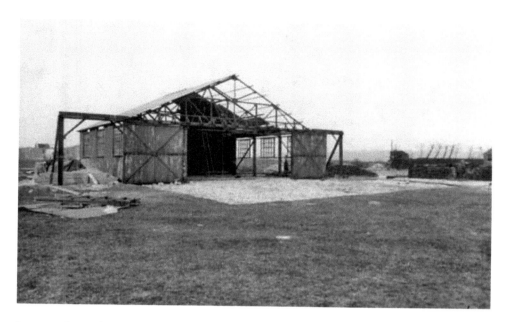

In 1938, the Yorkshire Aero Club rebuilt a Robin hanger to replace the earlier ones.

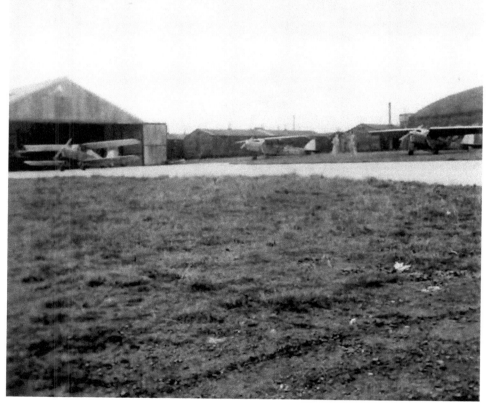

A Robin and the Bessoneaux hangers at Yeadon, 1937.

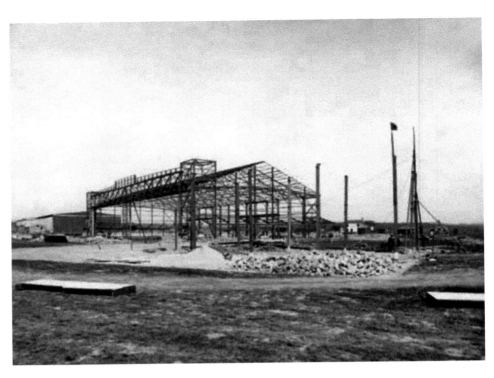

The municipal hanger in its initial stages of construction. (via Leeds Libraries)

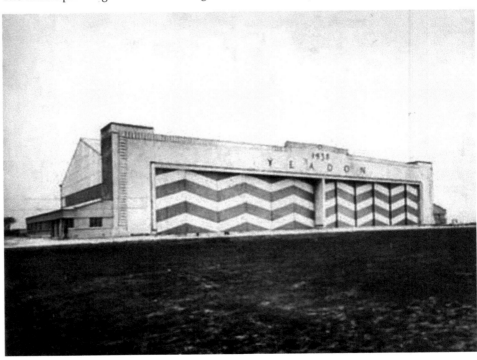

The municipal hanger completed in 1937. (via Leeds Libraries)

CHAPTER 3

The Second World War and After – The Military Presence

During the thirties there was a great deal of unrest throughout Europe. As a result, one saw a gradual build up of Britain's armed forces, especially the Royal Air Force, which had been drastically reduced after the First World War. Aerodromes throughout the country were upgraded: new hangars were built, runways were strengthened and resurfaced and facilities such as accommodation blocks were improved. Grass landing areas were replaced with concrete and asphalt runways capable of operating the heaviest aircraft. Gradually the Royal Air Force was being modernised with new, faster and heavier aircraft; the old biplanes that were such a common sight in the twenties and early thirties gave way to the streamlined monoplanes that were entering service.

The Royal Auxiliary Air force was formed in 1924 as a reserve, providing a primary re-enforcement capability for active squadrons of the Royal Air Force and operating mostly from civil aerodromes. Most of the training of both pilots and air crew were done at the weekends and during the two-week summer camps. Initially the personnel were absorbed into existing squadrons but by the outbreak of the war, the auxiliary units became operational squadrons within the RAF.

It was not until 1936 that any military presence became evident at Yeadon. On 10 February No. 609 RAuxAF squadron, which became known as the West Riding Squadron, was formed. The squadron was supported by the Sixth Earl of Harewood, who became No. 609's first honorary Air Commodore, and Squadron Leader Harold Peake was the first Commanding Officer. Like most of the other auxiliary units, it was classed as a light bomber squadron equipped with Hawker Harts. This type was replaced in December 1938 by Hawker Hinds when the squadron was re-designated a fighter unit under the command of Squadron Leader Ambler.

A week before the outbreak of the Second World War the squadron received its first modern fighters, the famous Supermarine Spitfire Mk 1s, and left Yeadon for Catterick in September 1939, but returned to Yeadon in 1946.

Initially the squadron was accommodated in tents and one wooden hut located near the aerodrome's two Robin hangars and a corrugated steel one used by the flying club. The temporary accommodation was replaced by a permanent RAF camp just off the Harrogate Road, complete with four new Bellman hangars, accommodation huts, an administration building, workshops, stores, mess halls and classrooms, all of wooden construction. A new Bessonneau hangar was built nearby to maintain the squadron's Hawker Hinds.

During the next redevelopment phase, when the new municipal hangar was built, the RAF camp was moved from just off Victoria Avenue to just off White House Lane. The new camp was at least twice the size of the old and initially it was planned to build at least five Bellman hangers and one T2 hangar. As the municipal hangar had occupied more space than originally planned, only four Bellmans were built (two single and two double). Enough accommodation space was provided for personnel of two front-line squadrons. In 1940, a watch tower was built on the roof of the municipal hangar, which provided clear view over the airfield and its approach.

By 1938, the war clouds had spread across the continent of Europe, and it was just a matter of time before Britain would be at war. Therefore plans were put in motion to take over all civil aerodromes for military use, of which Yeadon was going to be one. Even the Yorkshire Aeroplane Club had formed a Civil Air Guard with a number of eager pilots, with their light aircraft ready to give assistance where possible. Flying training increased and even before the declaration of war, the Civil Air Guard was ready for any sort of action.

The outbreak of war brought the requisition of all aerodromes, as expected. All private and civilian flying was suspended and the majority of light aircraft came under the control of the military. Some civil flying did continue but was under the control of the Royal Air Force. Initially, Yeadon came under the control of No. 13 Group Fighter Command, but on 1 September 1939 this was changed to No. 12 Group Fighter Command.

During the period known as the 'Phoney War' the aerodrome was used as a scatter field (satellite) for Armstrong Whitworth Whitley bombers of Nos 51 and 58 squadrons based at RAF Driffield and Linton on Ouse, which at that time were under the control of No. 12 Group.

On 6 October 1940, No. 4 Bomber Group Central Maintenance Organisation was formed at Yeadon and the unit took over two of the Bellman hangars to carry out major overhauls for No. 4 Bomber Group. At first the aircraft were mostly Whitleys and Wellingtons, but these were gradually replaced by the Halifax bomber, which became a common sight at Yorkshire's airfields. Working in conjunction with the maintenance facility was No. 4 Group Communication Flight, which was established at the airfield.

Within a year, neither Fighter nor Bomber Command had further use for the airfield, so on 17 March 1941 it was transferred to No. 51 Group Flying Training Command. The first unit to be based at the airfield was No. 20 Elementary Flying Training School (EFTS), equipped with De Havilland DH82 Tiger Moths. No. 20 EFTS was responsible for training thousands of pilots who proceeded to various establishments for further training and eventually to an operational training squadron. Then, within the next few months No. 51 Group, Communication Flight was formed, flying DH Rapides and Tiger Moths.

In 1940 the Ministry of Aircraft Production (MAP) built a shadow aircraft factory on land acquired at the north end of the airfield, adjacent to the A658 Harrogate road. Within a year heavy plant machinery was installed, ready for production. A flight shed was constructed near the RAF camp and next to the municipal hangar. A thirty-foot metal causeway was built connecting the factory with the airfield. The grass strip was re-enforced with stones and ash from surrounding gasworks and power stations. It was eventually replaced by concrete and asphalt later. MAP took control of the airfield, with the training school remaining as lodger unit.

When the shadow factory was completed it was handed over to the Avro Aircraft Company, whose main factory was at Woodford, Manchester.

The shadow factory was a very impressive installation with the main area underground covering some 1,514,190 square feet. It was regarded as one of the largest units under one roof in Europe. The factory was set out as a single unit, divided into square sections with a roadway around each side. Built of reinforced concrete and bricks and covered with earth, it could withstand a fair amount of bombing if required. It was mentioned a few times in the propaganda broadcasts by Lord Haw Haw but the German bombers never found out its exact location. MAP went to great lengths to ensure the factory was well camouflaged. The flat roof gave the impression of a flat countryside with a farm house and out buildings surrounded by a brick wall complete with dummy animals in the farm yard and, although according to some local inhabitants they could not recall seeing any, sheep were allowed to keep the grass short. Like all the aircraft companies, there was a constant pressure on Avro to supply aircraft for the RAF. However, it was found that the local area could not provide the large workforce required for aircraft production. Labour shortages were acute in West Yorkshire, so additional workers were drawn from both sides of the Pennines, the North of England and as far down as the West Country.

At its peak around April 1944 the factory employed a total of nearly 11,000 people, ranging from skilled mechanics and technicians to canteen workers and cleaning staff. Only 47 per cent of the total were male; the rest were women of all ages, both single and married. The limited accommodation available in the surrounding area proved to be a major problem for Avro and the Ministry. MAP decided to construct three complete housing estates in the vicinity of the factory. In all there were nearly three hundred temporary accommodation blocks, wooded and Nissen huts. A hostel was also built at nearby Horsforth, Greenbank Hostel, which stood on the site where St Margaret's estate stands today. The hostel consisted of long rows of prefabricated buildings with adjoining corridors and was able to cater for over 700 workers. Some of the technicians, engineers, designers and the Ferry Pilots were billeted in the RAF camp.

To cope with the task of finding accommodation a special billeting officer was appointed who managed to find lodgings in various parts of Leeds, Bradford, and Wakefield and as far as areas around York. Some workers had a round trip of well over sixty miles every day. To transport this work force to and from the factory was a mammoth task involving a fleet of buses and lorries.

The aircraft would be towed from the factory to the adjoining airfield, where the engines and controls would be tested. Ansons and Lancasters would be regularly seen taxiing up and down the runways prior to their initial flight by Avro or RAF test pilots. On many occasions one would see rows of aircraft parked in every available space awaiting distribution, which was the task of the Air Transport Auxiliary pilots, most of whom were women based at Yeadon. The aircraft would be flown either to a Maintenance Unit for storage and acceptance or direct to the squadrons.

The first aircraft to be assembled at the shadow factory by Avro was the Armstrong Whitworth Albemarle, a twin engine reconnaissance bomber. But production was curtailed as the aircraft was found to be unsuitable for operations and never went into full production.

In October 1940, Avro was awarded a contract to build the single-seat Hawker Tornado fighter, which was to be the successor to the Hurricane, because the Hawker Aircraft Company was heavily involved with the Hurricane production for the Battle of Britain,

So, Avro passed on the work of building and testing the new aircraft to the Yeadon factory. Although the successful team under Sir Sidney Camm designed the Tornado, the aircraft was dogged with problems from the beginning, mostly with its power plant, the new Vulture engine. It was planned that Avro would build 896 Tornadoes but this was abandoned after the completion of one aircraft (R7936) in July 1941. By the middle of the year Avro had completed a hundred sets and five complete aircraft at the shadow factory, which had been transported by road to Woodford, Manchester, where some experimental test flying was conducted before the project was eventually cancelled.

As far back as 1935, the Avro design team had come up with a winning design in the shape of the Avro 652 airliner, meeting Imperial Airways' specification for a long-range, twin-engine light transport. The Avro 652A Anson was in response to a specification by the RAF for a coastal patrol land plane. Within a few years demand for the aircraft increased, necessitating a second production line at the Yeadon factory.

The Anson, or 'Limping Annie' as it was affectionately known by the crew who flew her, was derived from the Avro 652 commercial airliner, which flew for the first time on 7 January 1935. The light bomber version, the Anson, first flew on 24 March 1935 in the capable hands of Captain H. A. Brown.

The first squadron to receive the twin-engine Anson was No. 48 squadron at RAF Manston in 1936, but when the war broke out in 1939 there were twelve Coastal Command squadrons equipped with the type. It continued to provide valuable service to RAF Coastal Command for a number of years, although by 1941 its front-line days were numbered as more modern types became available. The Anson was then withdrawn from front-line duties and used for training, light transport and communication duties.

Avro's Yeadon factory produced 3,881 Ansons of all marks, of which 2,368 were flown direct to the various squadrons and units, while 1,513 were crated and transported by road to ports or Maintenance Units. The actual break down of the different types built at the factory was as follows - 1,026 were completed with a Bristol-type dorsal turret, 2,770 without any turrets and 85 for communication and light transport. Also, it must be remembered that thousands of tons of spares were manufactured at Yeadon for distribution to Maintenance Units and units operating the type. The amount of spares was roughly equivalent to another 800 completed aircraft. During the 1943–44 a peak output of 130 aircraft a month came off the Yeadon production line.

The Anson production remained steady throughout the war, but as soon as there was a cessation in hostility production was reduced, although it continued well into the early fifties.

To the Air Ministry 's specification P13/36 for a medium bomber, Roy Chadwick's team at Avro, Woodford, designed and built a twin-engine bomber known as the Vulture-powered Manchester, which flew in July 1939. Due to the unreliability of its Vulture engines the Manchester was re-engined with four Rolls-Royce Merlin engines and renamed the Lancaster.

The first Merlin-powered Lancaster, L7257, first flew on 31 October 1941 from Woodford airfield. By the end of the war the bomber had been built at Metropolitan Vickers at Manchester, Vickers Armstrong at Chester and Castle Bromwich, Armstrong Whitworth at Baginton, and Austin at Longbridge as well as Avro at Chadderton and Yeadon. The Lancaster became the best heavy bomber of the war although it suffered horrendous losses.

As the Anson production line was wound down, spare capacity became available at the Yeadon factory and within months Lancaster rigs were installed.

The first completed Lancaster aircraft to leave the factory was in April 1942. Surprisingly, the King and Queen were visiting the factory at the time and as a special gesture King George autographed Yeadon's first Lancaster as it left the production line. A great number of the Lancasters built at Yeadon were for the famous Pathfinder Squadrons. These aircraft were fitted out with radar and electronic jamming devices in a quiet part of the factory, usually guarded by armed RAF personnel. While awaiting delivery, the Pathfinders' Lancasters were stored inside the Bellman hangars.

By the end of the war in Europe, production at the shadow factory had reached an outstanding forty Lancasters a month and the total built at Yeadon was 688 aircraft. At its peak one eyewitness remarked that the airfield was packed to capacity with Lancasters and Ansons as well as other various light aircraft, either waiting to be delivered or just parked.

During the war years the general appearance of the airfield drastically changed, from the grass aerodrome with a municipal hangar and a few buildings in 1939 to a fully equipped military airfield in 1945, complete with a concrete and asphalt runway, taxiways and parking apron, a typical Ministry watchtower and four Bellman hangars. After the shadow factory was built the municipal hangar that had dominated the aerodrome in the thirties was found to be inadequate and a new flight shed was built which could accommodate several Lancasters at one time.

The flight shed remained part of the airport infrastructure until the new terminal was built in 1982. When the war in Europe was finally over, the RAF still had a need for long-range bombers for the war in the Far East with Japan. A few Lancasters were converted for the task to equip the 'Tiger Force Squadrons', which was only a temporary solution. Avro came up with a larger version of the Lancaster bomber, namely the Lincoln. The first prototype (PW925), powered by four Rolls-Royce Merlin 85 engines, flew from Woodford on 9 June 1944. Later versions of the Lincoln were powered by the more powerful Griffon piston engines. The Yeadon factory was only involved with the manufacture of sections which were transported by road to Woodford for final assembly.

It was not only warplanes that the Yeadon factory built. The factory was heavily involved with Avro's transport aircraft, which were to become common in the post-war period in British civil aviation. These aircraft were the Lancastrian, a converted Lancaster bomber, and the true transport aircraft, the York, both of which were built at the Yeadon factory.

The Avro York first flew on 5 July 1942, but production was low key as the bombers had priority. It was towards the end of the war that the Yeadon factory became involved with its production. Deliveries to the RAF began in 1944 and by 1948 a total of 208 aircraft were in service with nine squadrons.

The Lancastrian was derived from Lancaster Mk X, utilizing a basic Lancaster 1 airframe adapted for transport duties. The aircraft had an elongated nose and tail sections with the

three turrets and bomb bay removed, allowing 3½ tons of mail and up to thirteen passengers to be carried. As the war drew to a close and the need for four engine bombers declined, all the Lancaster production rigs were dismantled and transported back to the Avro main factory at Woodford. The later versions of the Anson were still built at the factory well into the early fifties.

Yeadon Aerodrome never had the distinguished war time record of other Yorkshire airfields, but nevertheless Yeadon and its shadow factory will have a place of honour in history as it produced the essential tools for the ultimate victory. As the war in Europe and the Far East came to an end, the Auxiliary Air Force squadrons reverted back to their peacetime roll.

No. 609 squadron was reformed on 31 July 1946 as a night fighter unit equipped with de Havilland Mosquito NF 30s under the command of Squadron Leader P. A. Womersley DFC. For the next few years the squadron returned to Yeadon at the weekends. The Mosquitoes were stored at RAF Church Fenton during the week, flown to Yeadon on Friday evening and returned to Church Fenton on Monday morning. During April 1948, the squadron was re-designated as a low altitude, fighter-bomber unit equipped with Vickers Supermarine Spitfire LF16s powered by a Packard Merlin engine. The aircraft were permanently based and stored in one of Yeadon's Bellman hangars.

On 1 September 1948, No. 609 squadron was joined by light Auster aircraft of No. 1964 AOP Flight of No 664 squadron which was formed at the aerodrome. The flight exercised in co-operation with the Army garrison at Catterick.

In January 1950, No. 609 RAuxAf Squadron moved to Church Fenton, where they eventually converted to jet aircraft, the Gloster Meteor F8. Austers of No. 1964 AOP Flight were based at Yeadon between 1953 and 1957. Also in 1957, No. 609 squadron, now under the command of Squadron Leader David Shaw, returned to Yeadon to be disbanded. The squadron put on a flypast in their Meteors, followed by an official ceremony attended by both RAF and civil dignitaries, several of whom had close association with the squadron during the war. With the disbandment of No 609 squadron, the military presence at the aerodrome came to an end. With the eventual building of the new terminal, the huts and hangars of the RAF camp were demolished.

As for the shadow factory, which is still there, the wartime camouflage has given way to a more reasonable decor and it is now used for light engineering and a business park.

During the fifties and early sixties, the Soldiers, Sailors and Airmen Families Association (SSAFA) held their annual air displays at Yeadon. The first display took place on Whit Monday 1952, which proved to be an outstanding success, attracting crowds of nearly 100,000 spectators from all over Yorkshire and Lancashire. As the first air display was so successful, it became an annual event, attracting large number of crowds each year contributing generously to SSAFA. Spectators were treated to all the new aircraft entering service with the RAF, Fleet Air Arm and United States Air Force.

By the early sixties, the airport was getting busier with civil flying and therefore in 1962 one witnessed the last SSAFA air display at Yeadon.

In more recent years, military types seen at the airport include Lockheed Hercules, Lockheed Tristar, BAe VC10 and Boeing C17 transport aircraft on troop movements. Occasionally, fighters

and bombers have made brief visits to the airfield including Phantoms, Canberras, Hunters and more recently Harriers, Sea Harriers, Tornadoes and the Red Arrows Hawk trainers. Aircraft of the Queen's Flight were also visitors to the airport over the years.

Thus there has been a full military presence at Yeadon from 1936–57 with an occasional visit since, but as the result of the SSDR and the reduction in RAF equipment the author doubts such visits will continue in the foreseeable future.

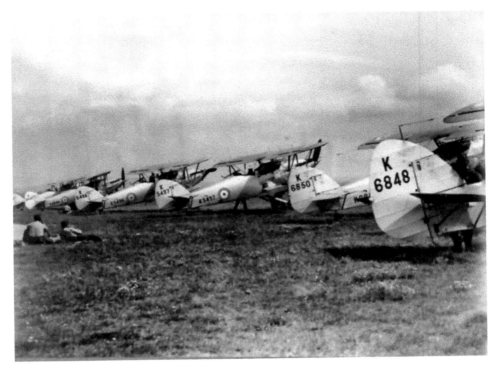

Line up of No. 609 Squadron's Hawker Hinds, 1938.

Anthony Eden visiting No. 609 Squadron, July 1941.

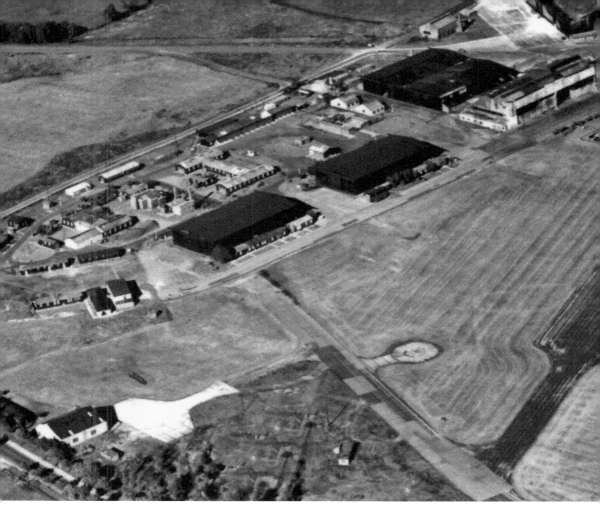

Aerial photograph of RAF Yeadon, 1945. (C. H. Woods)

Bellman hangers being built for the RAF. (via Leeds Libraries)

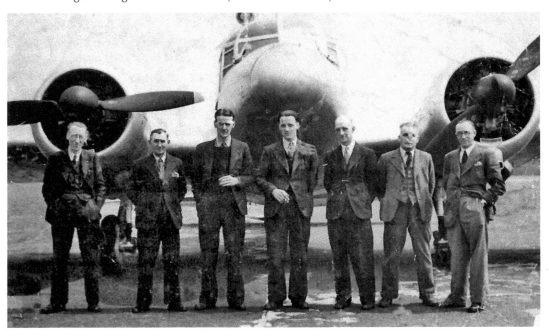

Anson production chaser at the Avro shadow factory. A total of 3,831 Ansons were built at the Yeadon factory.

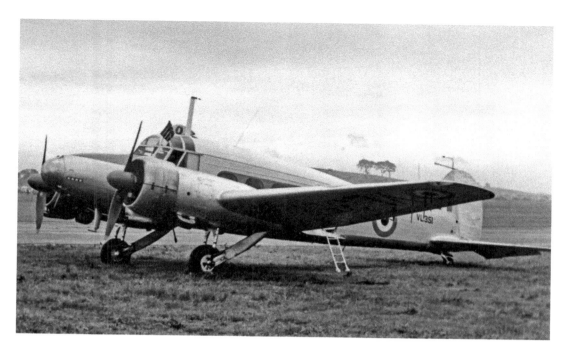

Avro Anson C19 at Yeadon.

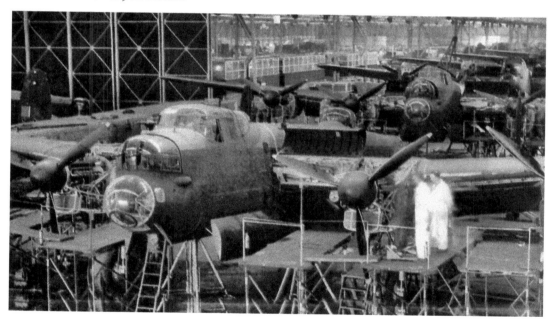

Lancaster production line at the shadow factory.

An Avro Anson taxiing past the Club House.

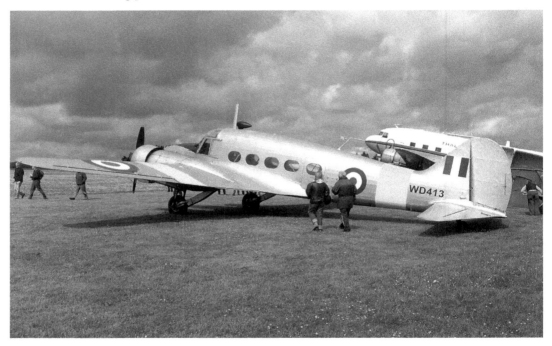

An Avro Anson built at Yeadon during the war. This one served with No. 1 Basic Air Navigation School and has been preserved. It is shown at Hullavington, Wiltshire, in 2005.
(© Adrian Pingstone)

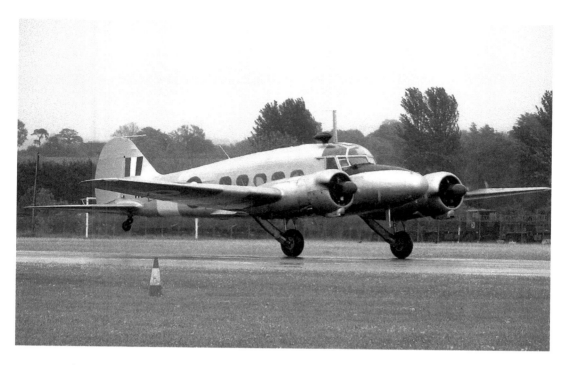

Bought by Air Atlantique in 1998, this Anson T.21 had also served with Bomber Command, Fighter Command and Training Command. (© Adrian Pingstone)

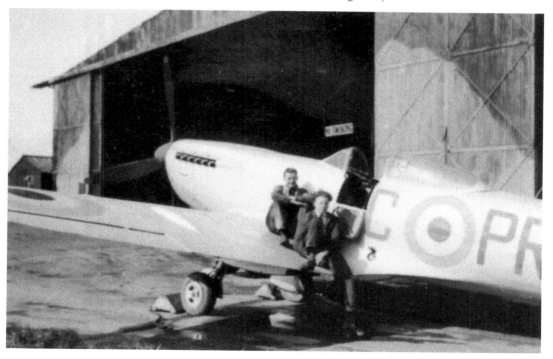

Spitfire of No. 609 Squadron at Yeadon.

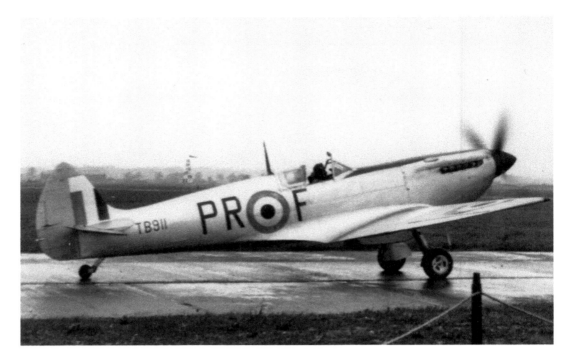

No. 609 Squadron Supermarine Spitfire.

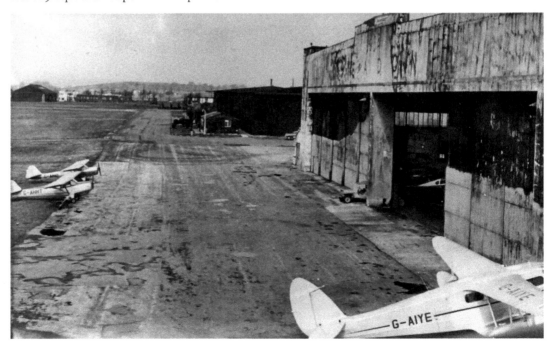

A post-war general view of the municipal and Bellman hangers.

DH Chipmunk of Leeds University Air Squadron outside Robin hanger.

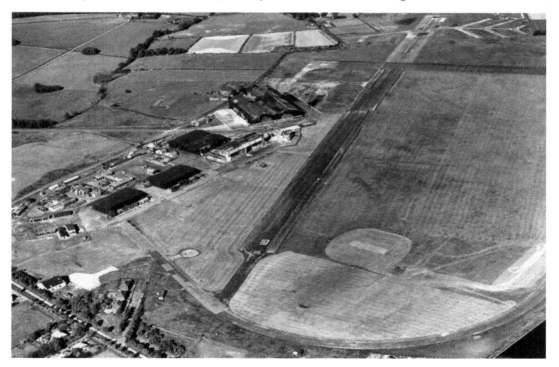

Yeadon Aerodrome as it was in 1947.

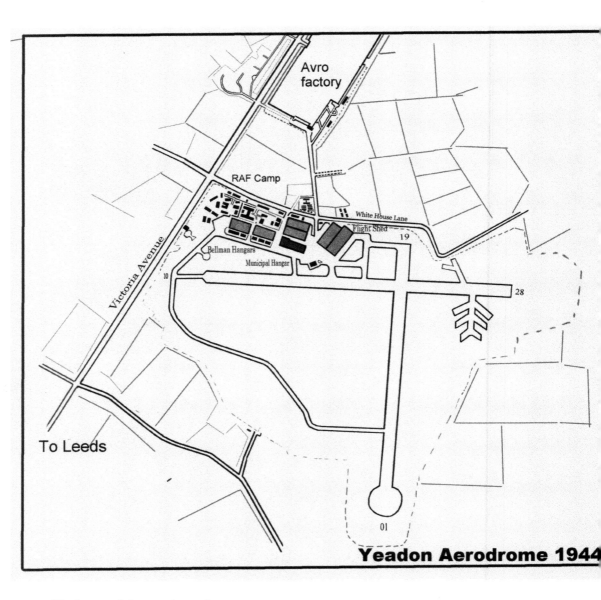

The layout of the aerodrome in 1944.

CHAPTER 4

The Post-War Period 1947–59

The airfield was returned to civil use by the Ministry of Aircraft Production on 1 January 1947, although some military presence continued at Yeadon for some years after. By then the last of the warplanes had left the production line at the Avro shadow factory. The imported labour had also left the area and returned to their villages and towns, and the local workers were employed elsewhere or, like most people in post-war Britain, joined the dole queues. Avro still kept a skeleton staff at the factory, but only a trickle of Ansons came off the production line.

Control of the airfield was handed over to the Ministry of Civil Aviation, as were the majority of aerodromes in the country. The Ministry was responsible for the daily running of the aerodrome from maintenance to providing emergency cover. Civilian flying was encouraged to return to normal, or at least to pre-war times. Within a few months the Lancashire Aircraft Corporation (LAC) was granted permission to restart club flying, but as yet there was no sign of any of the pre-war scheduled services restating.

LAC saw an opportunity to begin a summer service to the Isle of Man using a newly acquired De Havilland Rapide and an Airspeed Consul airliner. At the beginning, traffic was very slow, but as the summer months went by passenger numbers increased and LAC became confident with their new service as extra flights were added.

Progress and expansion was extremely slow the following year. The Lancashire Aircraft Corporation continued to operate club flying and the summer flights to the Isle of Man and a few additional charters to Blackpool. Like the rest of the country, civil aviation was rather slow in returning even to its pre war popularity.

By the summer of 1950 LAC had drastically reduced its involvement with the aerodrome. A typical example of recorded aircraft movement in July, which was usually classed as a busy month, was 300 transport or commercial aircraft and 1,047 other types, of which military aircraft contributed over quarter of the traffic. Passengers handled by the airport totalled 906; again, a large percentage were visitors to the Avro factory. The years that followed were even worse, considering that the majority of municipal airports were expanding and developing new businesses and new routes. Even the summer flights to the Isle of Man and Blackpool ceased.

In February 1953, the Ministry of Civil Aviation handed the control and the running of the aerodrome back to its previous owners, Leeds and Bradford councils, who in turn appointed Yeadon Aviation to assume the day-to-day running of the airport.

Under new control private flying resumed, but after considerable advertising no airline came forward with any plans for scheduled services from the airport. Once again in a matter of few years doubts arose about Yeadon's future as a municipal airport; some people even suggested using the land for house building. Gradually, through the persistence of Yeadon Aviation and council support, flying gradually returned to the airport.

For a number of years the Isle of Man had been a favourite holiday destination for the people of West Yorkshire but since the disappearance of the Railway Air Service in the thirties and Lancashire Aircraft Corporation in the post-war period, it was rather difficult getting an airline interested in the route. However, in May 1955 Yeadon Aviation was granted a licence by the ATAC to operate a scheduled passenger service to the Isle of Man using a newly acquired De Havilland Rapide (G-AIYE). Pleased with the service, the company proposed a scheduled service linking Leeds with Bristol and Exeter but this was eventually abandoned to concentrate on their successful Isle of Man flights.

Towards the end of the year a new airline, BKS Air Transport, outlined a plan to operate services from Yeadon. BKS concentrated its operation in the north-east of the country, connecting the area with the rest of the United Kingdom. Throughout 1956/7 the airline built up a network of scheduled services from Yeadon to various destinations in the UK, such as to Belfast, Southend, the Isle of Man and to Jersey, which became a popular holiday destination. For the first time, they also operated regular scheduled weekly flights to the continent, to Dusseldorf in Germany and Ostend in Belgium. During the summer of 1956 daily services to Edinburgh, Glasgow and London Heathrow were added, but the latter was withdrawn in October due to poor support. The majority of the services were flown by the airline's Douglas DC3/ Dakota fleet. With the introduction of continental and Channel Island flights, HM Customs facilities were instituted at the airport in 1956, a good sign that Yeadon was on its way to becoming an international airport. For the next few years BKS became the main operator at Yeadon, providing several all-year internal schedule flights but mostly during the summer season.

On 21 May 1957, Silver City Airways began operating charters on behalf of Lancashire Aircraft Corporation (travel division) to the Isle of Man. These seasonal flights, with a return fare of £6 19s 6d, proved quite an attractive proposition to many holiday makers and most flights through the summer were at least 80 per cent full. Silver City used a Dakota on the route but occasionally the larger Bristol Wayfarer, a passenger version of the B170 car freighter.

The first time the airline used their Wayfarer it caused some excitement and curiosity, just as when Sir Alan Cobham landed a Handley Page, *Prince Henry*, in the thirties. By the end of 1957 all elements of the Lancashire Aircraft Corporation were taken over by Silver City Airways.

With an increase in traffic and passenger numbers, Yeadon Aviation foresaw the introduction of larger and heavier commercial airliners, especially the new turbo props that were replacing the piston engine aircraft on most routes within the British Isles.

In 1958, the airport company decided to resurface the two original runways, 10/28 and 1/19, which had been constructed during the war. This modest development brought the runways up to a reasonable standard for operating the newer aircraft, but their lengths were still insufficient for future operations that other airports were aiming for.

Other developments were the installation of a new permanent airfield lighting system and up-to-date approach lighting on the main runway (10/28). A new aircraft parking apron was built to cope with the insufficient aircraft parking space available. On the passenger side an extension was built to the terminal, enabling it to handle twice the number of passengers.

On 1 January 1959, the Leeds/Bradford Airport Committee assumed responsibility of day-to-day running of the aerodrome and on 8 January the aerodrome officially became Leeds/Bradford Airport. As Mr G. P. Sellers was already manager with Yeadon Aviation, he was an obvious choice to be the first Airport Director, or Airport Commandant as the post was then known. During his twenty-one years as Airport Director he saw considerable changes in the airport's appearance and operations with which he was personally involved with the planning and redevelopment. Another personality that contributed a great deal to the early development of the airport was its admin officer, Mr Clifford Walker, who together with Mr Sellers became an efficient team during those early development years.

By the end of the year passengers using the terminal had risen to 44,740, while the aircraft movement had increased to 24,257. Air freight had increased to 320 metric tons, which was a modest increase compared with movements and passengers.

It was the contribution of private light aircraft that increased the aircraft movement figures, as by the late fifties private flying had increased considerably in all parts of the country. Most of the new aircraft were of United States origins as the British light aircraft industry had declined although there were still a great number of Austers and Tiger Moths flying with a number of clubs.

In January 1959, the Yorkshire Light Aircraft company was formed to overhaul and maintained privately owned light aircraft that were based at the airport. Initially Yorkshire Light Aircraft occupied two ex-RAF Bellman hangars but when they were demolished, the company moved into a new purpose-built maintenance hangar on the south side of the airport.

The year ended on a high note with the introduction of a new scheduled service operated by North-South Airlines to Bournemouth and the Isle Man using either a Douglas Dakota or a sixteen-seat De Havilland Heron. The airline had ambitious plans for the following year but sadly, due to financial problems the new routes never materialised and the airline ceased operating.

At last the airport had come out of the doldrums, with the future looking better than a decade earlier. Airlines had come and gone and a number of new services were introduced. New destinations in Britain and the Continent had come within easy reach of Yorkshire: Belfast 1 hour 25 minutes, Bournemouth 1 hour 30 minutes, London 1 hour 20 minutes, Newquay 1 hour 45 minutes, Jersey 2 hours 45 minutes, Brussels 2 hours 45 minutes, Dublin 1 hour 30 minutes and Dusseldorf 3 hours. All the flights were flown by piston engine aircraft; the turbo prop era was yet to come.

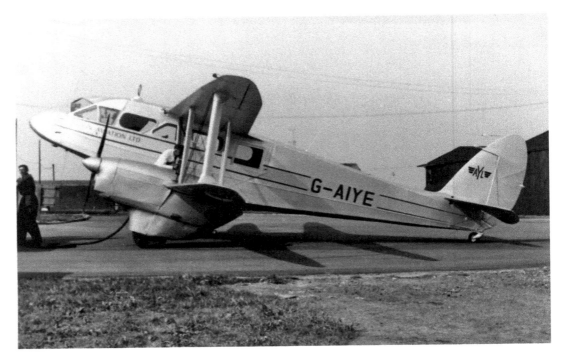

Yorkshire Aviation operated a de Havilland Rapide on flights to the Isle of Man.

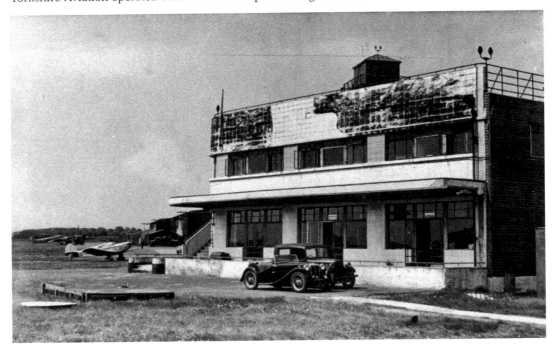

Yeadon Club House in the early 1950s. (via T&A)

An Avro Anson at Yeadon on 7 June 1954. It was operated by the RAF Home Command Communications Squadron. (© RuthAS)

A Chilton D.W.1 at Yeadon on 30 May 1955. (© RuthAS)

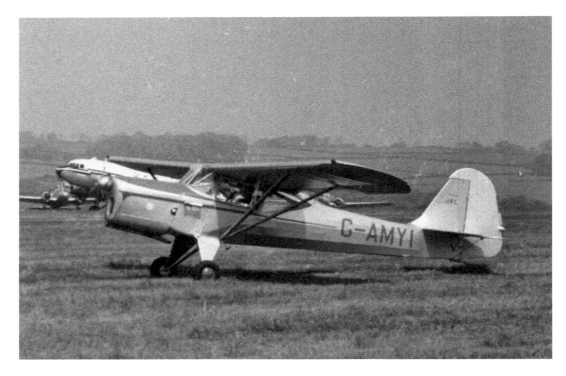

An Auster J8L Aiglet trainer at Yeadon on 30 May 1955. (© RuthAS)

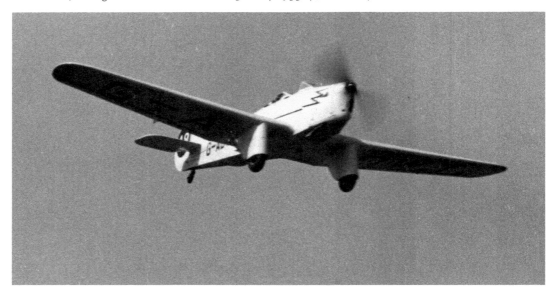

G-ADWT, a Miles M.2W Hawk trainer, on 30 May 1955. (© RuthAS)

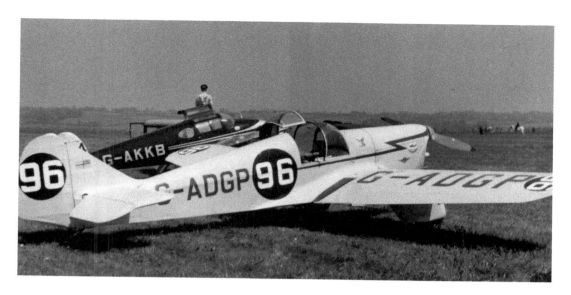

A Miles M.2 Hawk Speed Six in racing colours, May 1955. (© RuthAS)

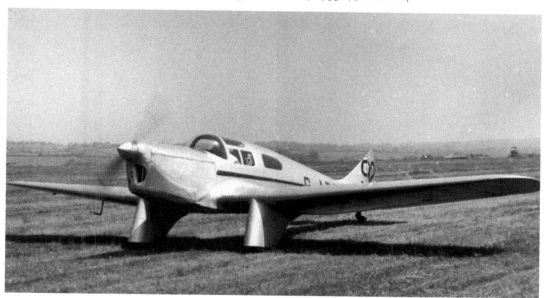

G-ADTD, a Miles M.3D Falcon, at Yeadon, May 1955. (© RuthAS)

G-AJRT, a Miles M.14a Hawk coupé at Yeadon, 30 May 1955. (© RuthAS)

A Miles M.77 Sparrowhawk takes part in an air race at Yeadon, 30 May 1955. (© RuthAS)

Miles M.18 Mk 2 G-AHKY at Yeadon in May 1956. Note the racing number on its tail. (© RuthAS)

De Havilland DH.84 Dragon G-ACIT of Air Navigation & Trading, based at Squire's gate, Blackpool, at Leeds-Bradford on 21 May 1956. (© RuthAS)

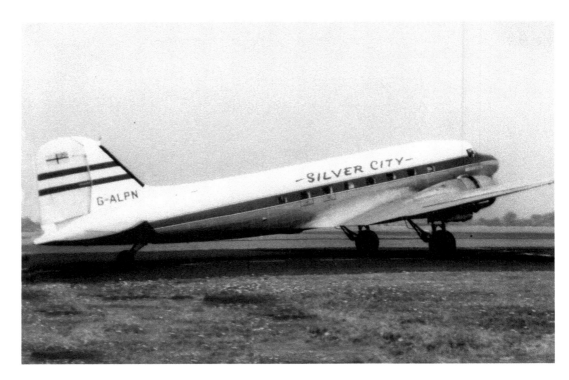

Silver City Douglas Dakota.

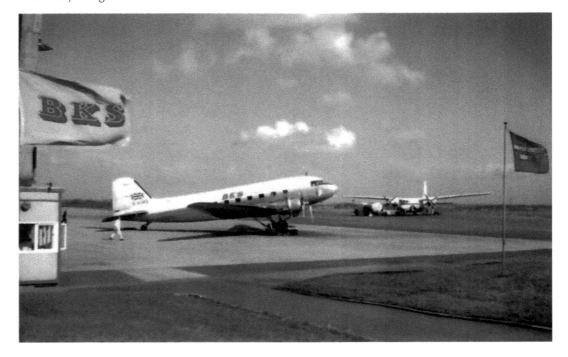

BKS Dakota just arriving at Yeadon.

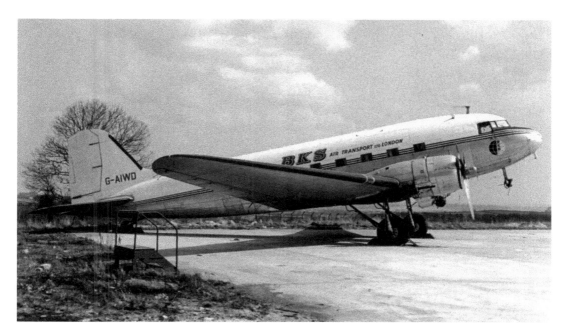

BKS Douglas C47 Dakota G-AWID parked at the aerodrome, 1965.

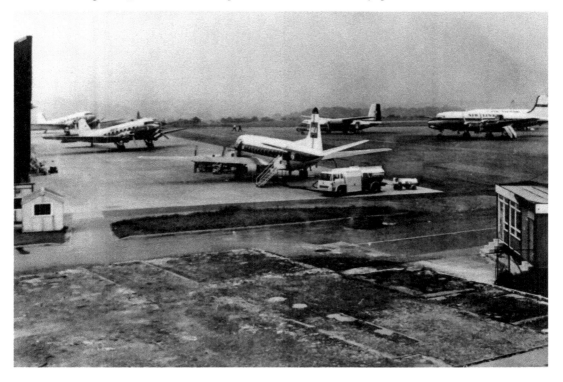

A busy apron in 1963. (via *Yorkshire Post*)

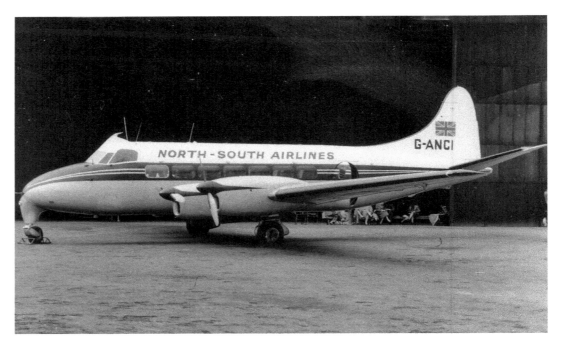

North–south de Havilland Heron at Yeadon, 1959. Note the crew relaxing in the flight shed.

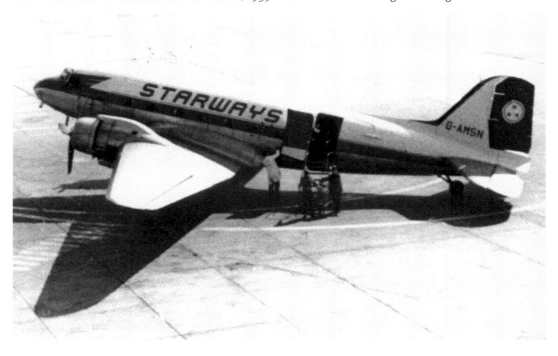

A Starways Douglas Dakota on the apron at Yeadon.

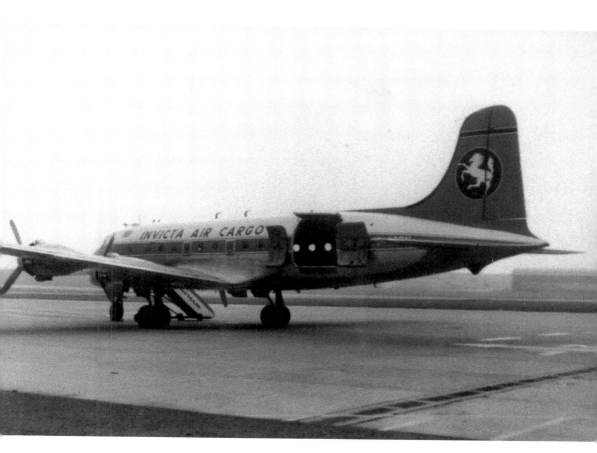

Invicta Air Cargo Douglas DC6 at Yeadon in 1967.

A Miles Gemini parked in front of the municipal hanger during an air display in 1959, with the club house and flight shed in the background.

CHAPTER 5

Turbo Props and the Jet Era (The Sixties)

Civil aviation in the UK in the sixties was advancing at a fast pace. Airlines were modernising, re-equipping and replacing their elderly piston engine aircraft with turbo-props and even pure jet liners. National airline BOAC had just placed an order for the Vickers Super VC10, while the other state airline, BEA, placed an order for the tri-jet DH121 Trident to supplement its recently acquired 139-seat Vanguard turbo props, which replaced the airline's Viscount airliners on its prestige routes. However, Leeds Bradford airport did not benefit greatly from what was happening either in the nationalised state airlines or elsewhere in the UK.

By early sixties BKS Air Transport had fully established itself as one of the main airlines in the country. In the sixties, the airline reintroduced its Leeds–London service, which it had dropped months earlier due to poor load factor. The new service was inaugurated in the spring of 1960 with a twice-daily Douglas Dakota service to London Heathrow. In April, the Irish national airline Aer Lingus began a daily service between Leeds/Bradford and Dublin. The service was shared between Aer Lingus and BKS, which was quite a unique arrangement at the time. The partnership continued until BKS was absorbed by Northeast, which dropped the route altogether, leaving the Irish airline the sole operator.

Passengers handled by the airport terminal in 1961 rose by over 29,000 travellers on the previous year, while aircraft movements increased by nearly 5,000. Scheduled flights continued to be the mainstay of the airport but only increased slightly. The most noticeable increase was the seasonal holiday flights, especially to the Channel Islands, as well as some Continental destinations like Ostend and the Dutch bulb fields in the spring.

Air accidents involving flights from Leeds Bradford were rare but in October 1961 a Leeds/Bradford based BKS Dakota G-AMVC crashed on the south-eastern side of Carlisle Airport, killing its crew of four. The aircraft had been charted by a group of farmers from the Carlisle area, but due to bad visibility the aircraft never reached its destination.

The first turbo-prop seen at the airport was on 1 April 1962, when Aer Lingus introduced a Fokker F27 Friendship on its schedule flights from Dublin. The airline had only taken delivery of the new forty-seat Fokker F27 Friendship on 20 February and Leeds/Bradford was one of the first destinations to be honoured with the introduction. The pressurised F27 was much faster than the conventional piston types previously used on the route and the flying time to the Irish capital was cut by half. BKS expansion had been fairly rapid, but by the early part of the sixties the company was in serious financial difficulties and in 1962 a receiver was called in to wind

up the airline. After some considerable consideration the receiver decided to let the company continue to trade but was recommended to sell its assets, including its fleet of Dakotas, and lease brand new Avro 748 turbo props and crews from Skyways. At last BKS had a modern airliner that was able to compete with other airlines like Aer Lingus.

The Dart-powered F27, the Vickers Viscounts and the Avro 748 dominated the scene for years to come as world airlines replaced their ageing piston engine Dakota fleets on domestic feeder routes.

During the 1962 summer season, Silver City Airways operated regular services to Jersey and Isle of Man using Dakotas or Wayfarer, but sadly this was the airline's last summer schedule as before the end of the year the airline shares were taken over by Air Holdings, the parent company of British United Airlines, of which Mr Freddie Laker had become the managing Director. Silver City continued to operate under its own name until the end of the year.

Another new turbo prop made its appearance at the airport during 1962, this being a Vickers Viscount of Starways of Liverpool. The airline operated a service between Leeds/Bradford and Newquay during the summer months. The service proved to be a disappointment and only lasted one short season.

The Vickers Viscount was the most successful of all British-built passenger airliners and became a common sight at most airports throughout the world until the introduction of the pure jet aircraft. The last Viscount to operate from Leeds/Bradford airport belonged to British Air Ferries and was on a charter flight to the Channel Islands in 1987. Nearly 450 Viscounts were built and served faithfully with all the major airlines of the world.

With the introduction of new heavier equipment and new routes, the Airport Committee agreed to further expansion, which included a new runway and a new terminal to handle the increased passenger movements as well as an upgrading of other amenities relevant to the smooth running of a modern airport. As usual, there was a great deal of hostility towards the proposed plans, mostly from ratepayers living in the vicinity of the airport. There was so much hostility that at one point in the procedure Wakefield Chambers of Commerce suggested that any further development at the airport was a waste of money and would be better spent on developing a completely new site, such as at Elvington near York which already had a superb 9,800 ft runway and at the time was only used as a relief landing ground by RAF Church Fenton. Eventually the go-ahead was given for the modest redevelopment of the airport.

Work began on the first phase of the redevelopment in 1963/65, when a new 5,400 ft runway (15/33) was built in October 1963 and was completed in April 1965, ready for the summer seasonal flights. The new terminal building on the site of the RAF camp took a little longer as work did not begin until December 1965 and then only became a priority as a result of the fire on 8 May 1965 when all the passenger accommodation was totally destroyed. A temporary passenger terminal was constructed in part of the old Avro flight shed, but was soon found to be inadequate and too draughty.

In 1966 the artist, Philippa Threlfall was commissioned to do a large mural to cover one of the walls of the restaurant and viewing gallery. The 6 ft by 8 ft mural depicting life in the West Riding of Yorkshire was completed a year later. However, the mural was demolished during the redevelopment in the late nineties.

In 1964 the Isle of Man service was taken over by British United (Manx) Airways using Douglas Dakotas and Dart-powered Handley Page Herald airliners. Also in 1964, Northair Aviation Group was formed at the airport by Mr E. Crabtree, which traded as Northern Air Taxi, in later years changing its name to Northair. The company soon became another successful Yorkshire aviation business with a purpose-built headquarters and a maintenance hangar as well as its own passenger terminal for the air taxi service. Later, the firm became the north's main agent for the famous Cessna Aircraft Company of America.

In July 1965, Yorkshire Light Aircraft expanded their business. New premises were acquired and a new maintenance hangar was built on the south side of the airport. In later years the company became the main distributor for Rolls-Royce/Continental light engines and was appointed authorised agent for the American Piper light aircraft. On 23 April 1966, an Iceland-based United States Navy Lockheed C121J Constellation landed at the airport. The four engined aircraft was on a return journey from Spain where it was involved in searching for a Boeing B52 bomber and its nuclear weapons that crashed just off the Spanish coast. The aircraft stopped at LBA to refuel and for crew rest.

The new control tower that was located on the roof of the terminal building became operational on 20 July 1967. At last the airport had an up-to-date tower equipped with the latest communication and navigational aids. Surprisingly, while all the construction work took place, the running of the airport was not affected. The same year the East Midland-based airline British Midland Airways, which had only recently changed its name from Derby Airways, began an East Midlands to Leeds daily scheduled service using either a Viscount or a Herald.

In 1967, BKS introduced a new all-freight weekday service between Leeds and Belfast with textiles manufactured in the Leeds and Bradford area. The aircraft used on the cargo flight was a cargo version of the Avro 748, with its seats removed. Seeing the potential of air cargo, Aer Lingus started a system of palletisation using specially adapted Viscounts in a passenger cum/freighter role, able to carry fifty-two passengers plus two pallets of freight on their Dublin service.

During 1967 the airport handled a staggering 298,060 passengers while aircraft movement rose to a peak of 42,788. The new terminal was finally completed in 1968 at the cost of £530,000. The magnificent building was capable of handling over 400 passengers per hour and was officially opened by the Rt Hon Earl of Scarborough, the Lord Lieutenant of the West Ridings, on 3 May 1968. In attendance were Ald J. H. Beherns, Chairman of the Airport Committee, Mr G. P. Sellers, and the Airport Director together with dignitaries from all over West Yorkshire, even those that objected to the expansion programme. The opening service was given extended press coverage, not only by the local newspapers, the *Yorkshire Post* and the *Telegraph and Argus*, but also by some of the national press including the *Guardian*.

The passenger terminal was an extremely modern complex and was regarded by many in the aviation business as the most modern air terminal in the UK. The terminal restaurant was renowned by both passengers and visitors alike, with first class food and a superb view overlooking the apron. On the rear wall was a mural in ceramic and stone created by Philippa Threlfall which extended for some eight feet in length and nine feet high along the rear viewing deck. On the outside adjacent to the terminal was a viewing area for plane spotters with its own

refreshment kiosk. On the wall separating the viewing deck and the restaurant was a memorial plaque commemorating No. 609 squadron and its close association with the airport.

On 24 May 1968, a special meeting of the Airport Joint Committee recommended an extension of the main NW/SE runway to the length of 7,300 feet to cope with the introduction of new jet aircraft entering service, but the airport had wait some years before work was completed.

For the rest of the sixties the regular scheduled flights continued to various destinations in the United Kingdom and the Continent. The summer seasonal flights provided the people of West Yorkshire with access to the Channel Islands, Isle of Man and for the first time regular IT (Inclusive Tours) flights to Barcelona, Gerona and Palma in Spain.

Regular airlines using the airport towards the end of the decade were Aer Lingus, BKS, BMA and BU (CI) on the scheduled services, while names like Air Ferry, Channel Airways, Invicta, Air Links and Martin Air Charters provided the IT flights.

Towards the end of the sixties a familiar name, BKS, disappeared from Leeds Bradford. Its London service had been taken over by Northeast.

Another airline that changed its name in the sixties was the Manx and Channel Island division of British United Airways, which became British United (Island) Airways, but the name did not appear at LBA until the following year.

Reflecting on the sixties with the introduction of the turbo-prop, it turned out to be quite an eventful decade. The airport had a new runway, a new terminal and an upgrade to its infrastructure. Passengers handled had gone up from 77,063 in 1960 to a staggering 297,493 in 1969, aircraft movements from 22,025 to 38,493 and freight from a mere 546 metric tonnes to 2,137 tonnes.

The decade turned out to be the beginning of IT (Inclusive Tours) flights from the airport. The regular flights to Isle of Man and the Channel Islands were always popular, especially when British United were advertising the 40 minute flight to the Isle of Man for a mere £3 12s one way.

Through the sixties the Dutch bulb fields became a popular destination during the spring months and flights to Amsterdam and Rotterdam became regular. Foreign airlines such as Martinair and Sterling Airways became common sight at Leeds Bradford Airport. Jet aircraft did make a brief appearance at the airport in 1969, but due to the length of the runway that were unable to take off fully loaded.

Fly British United to the Isle of Man from Leeds/Bradford for as little as £3.12.

(lowest single Tourist Class fare)

Just 45 easy minutes and you're abroad in the Isle of Man.

Ask your Travel Agent for

BRITISH UNITED AIRWAYS

Bardon Chambers, Infirmary Street, Leeds
Tel: (0532) 39124/6.

An advert for British United Airways.

DERBY AIRWAYS

1961/2 WINTER SCHEDULE

* * *

DERBY–BIRMINGHAM–CHANNEL ISLANDS
LUTON—DERBY—DUBLIN
DERBY—LEEDS—GLASGOW
DERBY—BIRMINGHAM—CORK

* * *

DERBY AIRWAYS

one of Britain's independent airlines

Derby Airways timetable, including flights from Leeds.

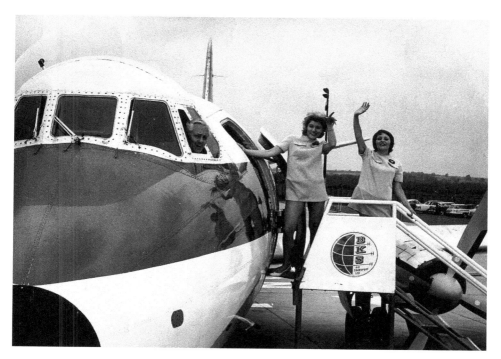

Hughie Green and his assistants pose for publicity shots for ITV's *Double Your Money* programme.

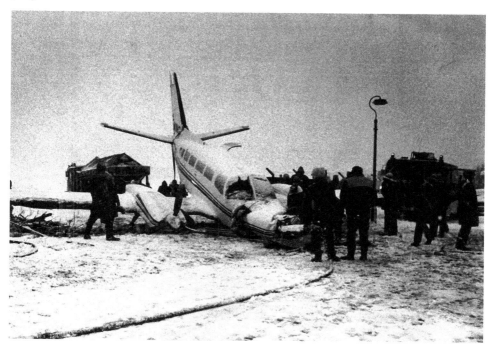

Accidents at the airport are very few and this one involved a privately owned Cessna, which overran the runway in a snow storm. (via C. Walker)

CHAPTER 6

The Jet Age Reaches LBA (The Seventies)

By the seventies, most of the British and foreign airlines were re-equipping with modern pure jet airliners like the Boeing 737, BAC One-Eleven, Douglas DC9 and the French Caravelle. However, many regional airports were found unsuitable for jet operations, which required longer and strengthened runways. At the time several British airports were involved in major expansion programme, re-building and extending their terminals, resurfacing runways and improving access to the airports.

The runways of Leeds Bradford airport were regarded as not suitable for pure jet operations. One airline suggested they were no better than some of the wartime airfields that had closed throughout Yorkshire. A new runway had been completed only seven years earlier, but by the early seventies it had deteriorated and it was far from being of a sufficient length to cope with the new breed of heavier turbo prop and jet equipment that required newer safety margins.

During a meeting in May 1968, the Airport Joint Committee agreed to plans to extend runway 14/32 to meet these new standards. As usual the airport was faced once again with objections to the plans from some of the local residents, especially those living on the airport approaches. It was not only the local residents that objected to the proposed plans; even some of the councillors were against investing more ratepayer's money on the airport.

The proposed extension, which was vital for the airport's existence, faced a bitter resistance from several quarters and after numerous heated debates and a Public Enquiry, the proposal was sent to the Department of Transport, who had the final say. In October 1970, the application was turned down by Mr Peter Walker, the then-transport minister, thus depriving the airport of a promising future. As one was to observe in later years, not only the airport and air transport suffered, but also light industry and investment in the area.

It took another ten years before Leeds Bradford Airport eventually got its 2,000 feet extension and then after another bitter fight with the same objectors, but the damage had been done. Other airports in other parts of the country were developed and their runways extended and in turn attracted new business and investment. Despite the serious set back the airport continued to operate.

By 1970 Aer Lingus was the sole operator on the Dublin route, and as the airline was first to introduce turbo prop to the airport years earlier, introduced the first jet equipment. Its Boeing 737 or BAC One-Elevens were often used on weekday flights, but due to the LBA runway length the aircraft had to be operated at a lower operating weight.

The name BKS had completely disappeared by early 1970; all its fleet of Avro 748s had been returned to Skyways and its successor Northeast, with Viscounts, became the most common sight at LBA. Although based at Newcastle, the airline used Leeds as its secondary base.

In 1972 British Midland had become a regular user of the airport but decided to withdraw its East Midland–Leeds–Glasgow service, which it had operated since it traded as Derby Airways. Fortunately for Leeds/Bradford the Scottish route was taken up by Dan Air, who had been waiting for an opportunity to include the airport in its route network. On 4 April 1972, a Hawker Siddeley (Avro) 748, G-ARAY, operated a proving flight on the newly acquired route, which was officially inaugurated a week later on 11 April. Ironically, the 748s operated by Dan Air had been previously used by BKS on service from LBA.

Skyways International and its fleet had been acquired by Dan Air during 1972. Leeds Bradford Airport benefited from the arrival of Dan Air as it brought with it ground handling and engineering facilities which remained at the airport until the early nineties. On 10 April 1972, the British Airways Board was formed to centralise all national and international services operated by BEA and BOAC. As a result, all British Air Service interests came under the control of British Airways Regional Division and Cambrian and Northeast disappeared altogether, with the routes taken over by BEA. In 1974 the Norwich-based Air Anglia made its debut at LBA, when on 6 May it began a scheduled weekday service from Norwich to Edinburgh and Aberdeen via Leeds. The aircraft used on the route was a Fokker F27 Friendship, G-BAUR, which became a regular visitor at the airport.

In 1974 the airport handled a total of 44,435 aircraft movements, while the terminal handled 283,570 passengers. Despite not having a sufficiently long runway or modern infrastructure, the airport continued to attract interest.

In 1975, the Bristol-based airline, Severn Airways acquired a licence to operate service between Leeds Bradford and Bristol. The first proving flight on 18 March turned out to be a grand public occasion. The Lord Mayor of Bristol, Councillor A. G. Pegler, flew to Leeds where he was met by the Lord Mayors of both Leeds and Bradford and after a civic reception made the return flight to Bristol. The aircraft used for the flight was a De Havilland Dove, piloted by Pilot Officer S. Lefont, which took 75 minutes but the return flight took just over an hour. The actual daily service commenced a week later with a return fare of £23.50, but by the end of the month had increased to £28. Initial load factor was encouraging, so much so that the airline put forward plans to extend the service to Cork from Bristol, but the route never materialised. Even the service to Leeds was withdrawn in July 1975 because of the airline's financial problems. Soon afterwards, Severn Airways ceased operations altogether. Dan Air took over the route the following year with connections from Cardiff to the Channel Islands and the Continent. The airline's first flights to the south-west and south Wales took place on 6 January 1976 with a Leeds to Cardiff and a Leeds to Bristol service, but the return flight to Leeds Bradford was extended to Glasgow. The aircraft used on these inaugural flights were two Hawker Siddeley 748s, G-ARAY and G-BEBA.

Regular scheduled services from Leeds to the Channel Islands had lapsed since the disappearance of Silver City Airways. The summer seasonal flights had more or less continued but the all-year-round service had ceased. Air Anglia was the first to introduce a regular service

to Jersey, the first flight being on 27 October 1976 using the F27 G-BAUR. Also in that year Air Anglia began a daily service to Amsterdam.

The majority of regional airports in the UK had benefited from an upsurge in holiday charter flights to the Mediterranean regions. Leeds/Bradford was not so fortunate. Most of the IT flights from the airport were to the bulb fields of Holland or to Ostend. However, in the autumn of 1976 Thomson Holidays began selling holidays flying from Leeds/Bradford Airport. The first such IT flight was to Palma, flown by a Boeing 737 of Britannia Airways. This became the beginning of regular holiday flights by both Thomson and Britannia Airways and within a few decades thousands upon thousands of holiday-makers had flown with the two companies from LBA to various destinations.

Other airlines made a brief appearance at the airport in the seventies, such as British Island Airways during the summer, when it began a daily schedule service to Bournemouth with connections to the Channel Islands, but this only lasted for one season.

By 1978 Air Anglia withdrew from the Channel Island services as their aircraft were required elsewhere on more profitable and busier routes. Once again Dan Air saw an opportunity to expand its route network, especially in the north of England. The inaugural service between LBA and Jersey took place on 15 April 1978 using the 44-seat HS 748 G-BEKG.

On 4 May 1978, Air Anglia began its daily service from Leeds to Paris. In 1974 British Airways had ceased operating the Leeds to London Heathrow service, but kept the operating licence. However, when the licence became available it was taken up by British Midland and towards the end of the decade they began operating the prestigious route using Viscounts and Fokker F27s. On 3 November 1979, Air Anglia introduced the twice daily Leeds–London Gatwick service using its F27, but due to poor load factor changed to a smaller 19-seat EMB110 Bandeirante.

By the end of the decade there was a complete reorganisation taking place nationwide in the airline business. The aviation interests of the British & Commonwealth Shipping Group was combined into one organisation. British Island Airways was combined with Air Anglia, Air Wales and Air West to form Air UK, which gave the new airline a better opportunity to compete with other airlines, both in the domestic and international market.

Perhaps the seventies were mostly remembered for the introduction of turbo props on most routes, the jet aircraft and the beginning of the IT flights.

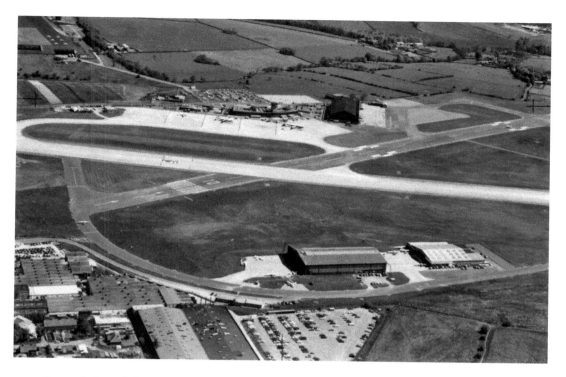

General view of the airport, 1977. (C. H. Woods)

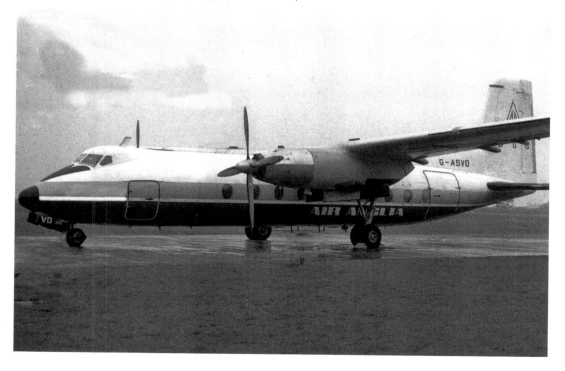

Air Anglia used Fokker F27 Friendships on the Leeds–London Gatwick service in the 1970s.

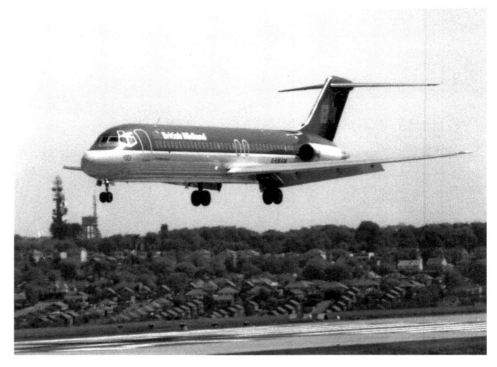

British Midland operated Douglas DC9s on their London Heathrow flights for years. This type replaced the turboprop Vickers Viscount airliners.

A Dan Air BAe 146 landing.

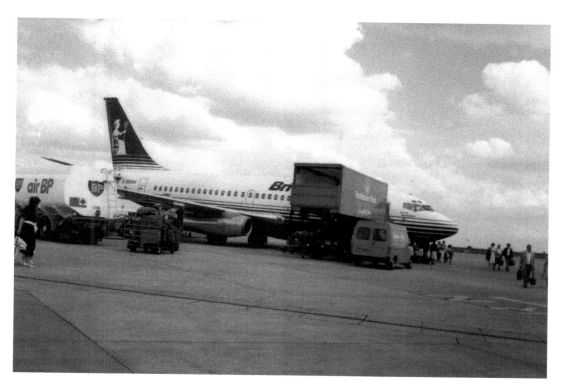

A Britannia Airways Boeing 737 being prepared for its next flight.

Two Britannia Boeing 737s on the apron at the height of the holiday season.

A Spanair-operated MD80 on the Palma holiday charter service.

Another Spanish airline, Hispania, operated IT charters from the airport in the 1980s.

CHAPTER 7

The Expansion Decade 1980–89

The eighties began as just a recurrence of the previous decade: an extended runway and a new larger terminal were urgently required if the airport was to compete profitably with other regional airports and cope with predicted increase in traffic. As usual there was still a great deal of hostility from some quarters to expansion. The Airport Committee had realised that to make Leeds/Bradford Airport successful and to attract new business to the area, the expansion had to go ahead. Already scheduled services to various destinations in the UK and the continent had doubled in the last ten years.

Ever since the introduction of the first direct holiday flight to the Mediterranean by Britannia Airways for Thomson Holidays in 1976, the Committee had seen that such holiday charters were going to be one of the main source of revenue for the airport. By the early eighties other major tour operators became interested in operating from LBA, such as Intasun, Arrowsmith, Horizon and Yugotours. In the spring of 1982, Mr Gordon Dennison became the Airport Director; he took over from Mr G. P. Sellers, who had to retire due to ill health after completing twenty years in the post.

As Airport Director, Mr Dennison was fortunate to witness a great changes at the airport, most of which can be credited to his sheer determination to continue where the previous director had left.

By 1980 there was already a steady increase in traffic movement and since the terminal was opened in 1968, over two million passengers had passed through its doors. It was obvious that the terminal as it was would not be able to cope with the predicted increase in future traffic, therefore new investment in the airport's infrastructure was urgently needed. This was one of the points put forward to the minister of transport who had the final say, but it took a further debate as well as a public hearing before the minister gave the go-ahead in January 1981. The massive £25 million investment secured the future of the airport, bringing it in line with other major airports in the UK. Half the cost was obtained from the Common Market in grants, while the rest was met by the ratepayers of West Yorkshire. The breakdown of the huge investment was as follows: £8.5 million on the runway extension, which meant a road tunnel to take the A658 access road; this tunnel contributed to most of the cost, as it was a major road linking Leeds and Harrogate and Otley – £4 million on the much needed freight area, which meant a new building to replace the wartime hangar; new navigation lights and a new apron lighting system which was long overdue. An additional £4 million was spent on upgraded radar system

to cope with the additional traffic. Also on the shopping list were new fire tenders, snowploughs and other airfield vehicles.

To handle the increase in passengers that was inevitable, a new terminal was built, while the existing one was modified and modernised. Finally, £3.5 million was spent on the cost of acquiring new land, professional fees, etc., as well as a large proportion allocated for anti-noise measures to try and appease some of the local residents.

Work on runway 14/32 began in 1982; it was extended by 2,000 feet, bringing it up to 7,380 feet. In parallel with the runway extension, work also began on the terminal and throughout the construction the airport continued to function with its day-to-day running. Not once did any flight have to be cancelled because of the redevelopment. During the construction phase, Mr Roy Minear, who was a Project Engineer with Leeds City Engineers Department and who also had previously provided technical support to the Airport Director, was appointed Assistant Airport Director (Administration and Finance). His duties included the supervision of all financial matters, apron handling, and security and terminal operations. His engineering knowledge was a great asset during the redevelopment stage. In July 1987, Mr Minear left Leeds/Bradford Airport to become Managing Director of Humberside Airport, where he remained until July 1989.

Total passengers handled during 1981 was only 351,000, a rather disappointing total considering the airport had a large catchment area compared with Newcastle Airport, which handled twice the number during the same period, mostly due to an increase in IT holiday charters. During the early part of the eighties there was a moderate air service between Leeds/ Bradford and London, with a British Midland service to Heathrow and Air UK to Stansted. Both the London airports were situated on the north and the west of the capital city. So in 1982 a new airline, Genair, began a twice-daily service to London Gatwick using a thirty-three–seat Short 3-30, connecting Yorkshire with South East England. Initial traffic on the route was quite encouraging, with a high load factor. Genair became a regular user of the airport until 1984 when, due to financial problems, ceased operations.

The British Midlands service to Heathrow was the most successful of the London services and it recorded a substantial 27 per cent growth in passenger traffic and announced that the airline intended to introduce the Douglas DC9 on the route as soon as the runway extension was completed. The news delighted the airport authorities as it would establish the airport's first regular true jet schedule service.

In 1983, the West Yorkshire-based Brown Group of companies formed a new airline, Brown Air, based at the airport. Initially the company began its operation as an air taxi service, flying its own executives and potential customers around the UK, but on 1 October 1984 it began a Leeds–Oslo scheduled service using a Cessna 441 Conquest (G-MOXY). Flights from Leeds to Frankfurt with stops at Humberside soon followed.

With the collapse of Genair in June 1984 another northern-based commuter airline, Air Ecosse, saw the potential of the London Gatwick service and within a matter of months took over the route. For the next few years Air Ecosse Short 3-30s and Bandeirantes served Leeds/ Bradford with London Gatwick as well as Humberside Airport until 1986, when the airline withdrew from the schedule scene to concentrate on charters and leasing.

Also in 1984 two feeder air services were formed in the UK, Connectair and Metropolitan Airways. These small commuter airlines connected regional airports with the main international airports like London, Manchester and Birmingham.

Metropolitan Airways, with the assistance of Dan Air, began feeder services connecting Glasgow, Leeds, Cardiff and Bristol. The first service was on 26 March 1984, Leeds to Glasgow and Leeds to Cardiff and Bristol using a 33-seat Short 3-30 (G-BGNA). The service was quite successful but like Genair the airline ceased operations in August 1985, whereas Connectair flourished and was eventually taken over by British Caledonian Airways.

The A658 road tunnel underneath the extended runway was officially opened on 1 March 1984 by Councillor T. E. Hall, Chairman of the Airport Committee, but it would be another year before the runway was ready for operations. The first aircraft to officially use the new extended runway was a British Airways Boeing 747, which became the first Jumbo Jet to use the airport.

Up to 1984 Aer Lingus had been using either Fokker F27s, Viscounts or, on special occasions, BAC One-Elevens on the Dublin services, but on 30 March 1984 the airline introduced the new 36-seat Short 3-60 to Leeds/Bradford Airport under the livery of Aer Lingus Commuter.

In 1985, after the extended runway became operational, there was a sharp increase in IT holiday charters from the airport. Up until then only Britannia Airways had been using Boeing 737 on their holiday flights, but on 2 May 1985 Britannia used their newly acquired Boeing 767 G-BLKW on a charter to Spain.

In the same year British Airways introduced the Lockheed Tristar to LBA, the first flight taking place on 6 May from the airport. However, on 27 May 1985 a British Airways Tristar, G-BBAI, was involved in a mishap, which could have resulted in a serious accident. The aircraft was on an inbound flight from Palma with 416 passengers and crew aboard, most of who lived in the West Yorkshire area. During the landing on a rather wet and slippery runway and in blustery rainy conditions, the aircraft ran off the end of runway 14/32. Within seconds the airport's emergency services as well fire tenders from the airport's vicinity were on the scene and in record time all the passengers had been evacuated from the aircraft. If it hadn't been for the magnificent handling of the aircraft by the pilot, the efficiency and professionalism of the crew and the quick reaction of the emergency services the incident could have been a major incident. After a lengthy inquiry into the accident, it was more or less decided that the cause of the accident was bad weather and a slippery runway because of the heavy rain.

The long awaited phase 1 development of the airport terminal building was finally completed and it was officially opened on 18 July 1985 by HRH the Duchess of Kent.

1986 saw the expansion of Brown Air when they were awarded CAA licence to operate a Leeds to Glasgow service, which was relinquished by Metropolitan Airways when it ceased operations. The company leased a 33-seat Short 3-30 on the twice daily flight, while the Cessna Conquest was used on flights to Frankfurt and Oslo. Also in January the airline acquired a Grumman Gulfstream from Priester Aviation of Chicago, which was flown directly to Leeds by Brown Air crew.

Most of the scheduled services during 1986 were operated by Air UK, their F27s connecting Leeds with Aberdeen, Belfast, Edinburgh, and Stansted in the British Isles and Amsterdam, Copenhagen and Paris on the continent. Weekend flights to Guernsey and Jersey were operated

by Dan Air using their Hawker Siddeley 748. London's three airports were served by British Midland five daily flights to Heathrow using DC9s, Viscounts or F27s, Gatwick by Air Ecosse twice daily flights to Gatwick using Short 3-30s and Air UK twice daily flights to Stansted using F27s.

Since the thirties Yorkshire had an air link with the Isle of Man and during the early part of the 1980s the weekend flights were operated by Jersey European on Sundays and Manx Airways on Saturday. Eventually Manx was to take over all the weekend flights from Leeds Bradford altogether.

No doubt the year will be mostly remembered for two memorable events. Firstly, during the summer of 1986, the Canadian airline Wardair introduced a weekly service to Toronto in Canada using a Boeing 747. The second event was in August, when the first Concorde belonging to Air France landed at Leeds Bradford. The aircraft, piloted by Captain Raymond Machavoine, made a perfect landing on runway 14/32 to the loud cheers of the people that gathered to witness the event. All the vantage points were occupied by sightseers and every road leading to the airport was blocked, which caused severe traffic problems for West Yorkshire Police; it seemed that the whole population of Leeds and Bradford had come to the airport. After the first prestigious visit, the Concorde attracted vast crowds every time it visited Leeds/Bradford Airport.

One important event that took place in 1986 was the Airport Act (1986), which stipulated that all airports, including Leeds/Bradford, with a turnover in excess of £1 million and owned by local authorities had to be formed into a limited company. As the result of the Act, in April 1987 Leeds/Bradford Airport Limited commenced trading with shares in the new company held by the five district councils in West Yorkshire, Leeds and Bradford each holding 40 per cent, while Calderdale, Kirklees and Wakefield held 20 per cent.

British Airways Concorde G-BOAE visited the airport on 24 April. Again it attracted a huge crowd, as did a Virgin Atlantic Boeing 747 on 11 June, which made a Gatwick to Leeds/Bradford flight. In 1987 Wardair was joined for a short period by Worldways Lockheed Tristar or Douglas DC8 flights to Canada, but they did not seem to be attracting any new passengers so withdrew the service at the end of the season. Sadly, Wardair withdrew the Canada service at the end of the 1988 season.

On 3 May, the airport had its first visit by an ultra quiet Boeing 757, powered by two Rolls-Royce RB211 engines, belonging to Air 2000 on charter flight to Faro on behalf of Arrowsmith Tours. Pop stars have also drawn the attention of the crowds at the airport. On 15 August, a Rombac-built One-Eleven on lease to London Express brought Madonna to Leeds for a concert at Roundhay Park.

In 1987, Brown Air added Cardiff to its growing route network, but decided to withdraw from the continental services and concentrate on the domestic market. Foreseeing the potential growth in the domestic sector, Brown Air placed an order for the new 39-seat Short 3-60 Srs 300 aircraft, becoming the first UK launch customer. The new aircraft, G-BNDM, entered service on 12 October 1987 and at the same time the airline adopted a new name and livery of Capital Airlines.

With the new runway extension and terminal the airport was geared for the nineties, but there was one stumbling block and that was the restricted operating hours. Scheduled flights

were not hindered by the 0700–2200 operating times, but it did deter a number of charter operators from using Leeds/Bradford. An application for extended operating hours was submitted to the Secretary of State, but a final decision was not made until 1989. 1988 was classed as a successful year although holiday charter passenger figures had dropped by 18 per cent on the previous year. There was a sharp increase in scheduled service passengers, mostly due to Capital Airlines acquiring new routes. British Airways Concordes G-BOAF and G-BOAD made two separate visits to the airport in May 1988, one being an overnight stopover. Total passenger figures for the period 1988/89 were 739,270, an overall increase of nearly 10 per cent over the previous period. Scheduled service passengers had risen by a spectacular 34 per cent on the previous year to a total 507,200.

The gap left by Wardair when it withdrew the Toronto service in 1988 was taken up by a new airline, Odyssey International. The new carrier operated a direct weekly service to Toronto using a Boeing 757 aircraft. Throughout the year, passengers handled at the airport rose dramatically, especially during the summer months, one of the best being July when the total of 34,572 passengers were recorded – a massive 307 per cent increase on July 1988. August was better still: 2,411 aircraft movements occurred, a 19 per cent increase. So, during the first eight months of the year nearly 600,000 passengers passed through the airport. The year produced its usual flight delays, which meant a number of angry, stranded holiday-makers. The biggest problem experienced at the airport was the collapse of the Spanish airline Hispania, when hundreds of holiday makers were stranded at the airport and in Spain until the tour companies found other airlines.

On 14 and 15 July, two Hispania aircraft, a Boeing 737-300 and a Boeing 757, were impounded by the authorities at the airport, as were the airline's other aircraft at Cardiff, Manchester, Teeside and Birmingham.

Finally, the Secretary of State gave his decision in August 1989, authorising the airport to extent its operating hours. The 0600–0100 hours were rejected in favour of retaining the present 0700 opening, but the evening operations were extended from 2200 to 2330. After an appeal a concession was made that the airport could remain open until 0100 hours to cater for an incoming flight, but there would be no take offs permitted after 2330. Within days the authority submitted an application for twenty-four-hour operating, knowing that it would be well in the nineties before a decision was given.

The decade eventually turned out to be the most memorable years in the history of the airport. LBA got its runway extension, a new extended terminal and even extended operating hours. New airlines and new aircraft opened up new routes, traffic increased on existing domestic and continental routes, and even cargo traffic went up but not as much as other regional airports. But the eighties will mostly be remembered for the new aircraft that made their debut at the airport, including the Boeing 747 Jumbo Jet, the Tristar, Boeing 757, European Airbus A300 and A310 and, of course, the pride of all modern airliners, Concorde.

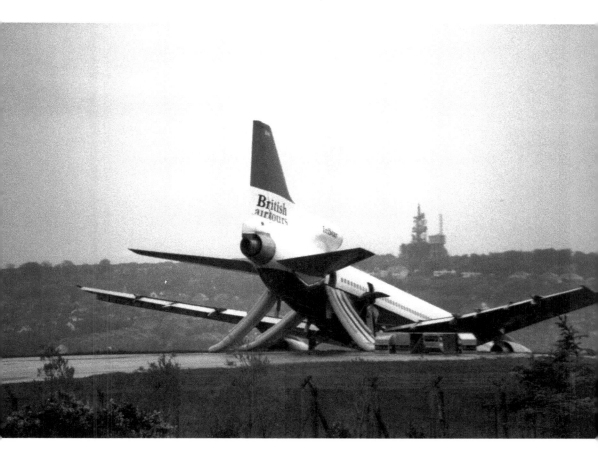

A British Airtours Lockheed Tristar overshot the runway on 27 May 1985.

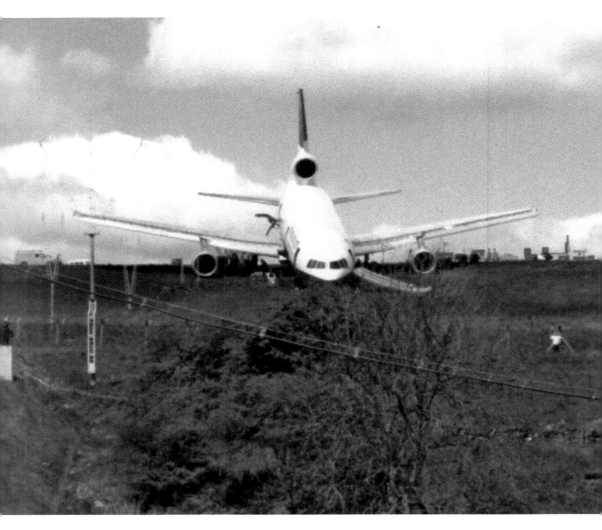

G-BBAI, a Lockheed L1011 Tristar of British Airtours en route from Palma, Majorca, overran the runway on 27 May 1985 after a landing on the wet runway after a rain shower. The passengers and crew all escaped with only a few minor injuries and the aircraft was recovered a couple of days later. The aircraft still survives in storage at Abu Dhabi after a flying career spanning from 1975 to 1990. (© Thedarkarches)

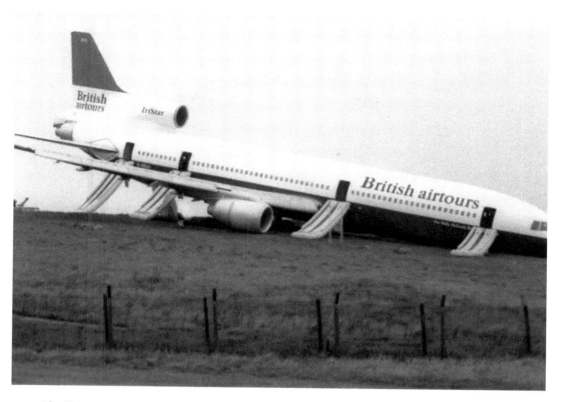

The Tristar came to rest in a very precarious position at the end of runway 14/32.

Dan Air operated BAC One Eleven aircraft on a number of IT holiday flights and weekend services to the Channel Islands.

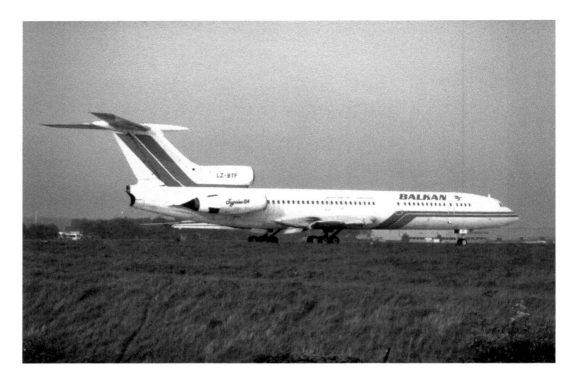

Throughout the 1980s, Balkan Airways Tupolev TU154s flew from the airport.

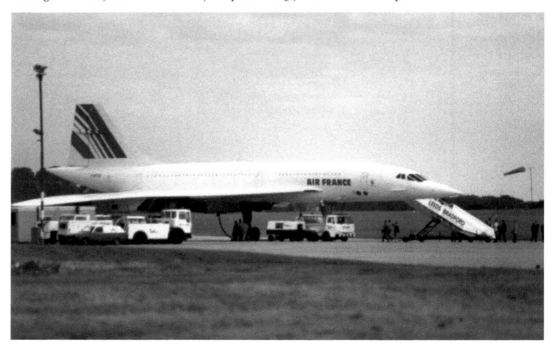

The supersonic Concorde was always a crowd-puller at Leeds Bradford. The first Concorde flight was by Air France in August 1968.

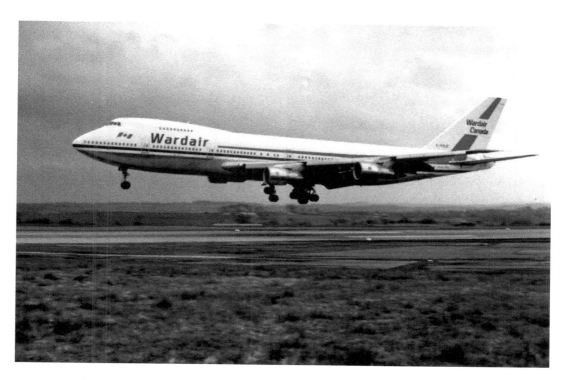

A Wardair Boeing 747 Jumbo Jet is seen here landing after a transatlantic flight.

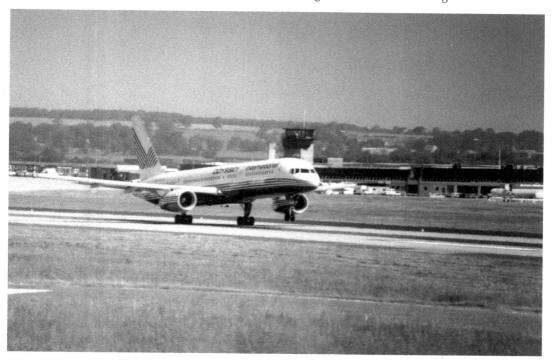

Odyssey International took over flights to Canada from Leeds Bradford in 1989.

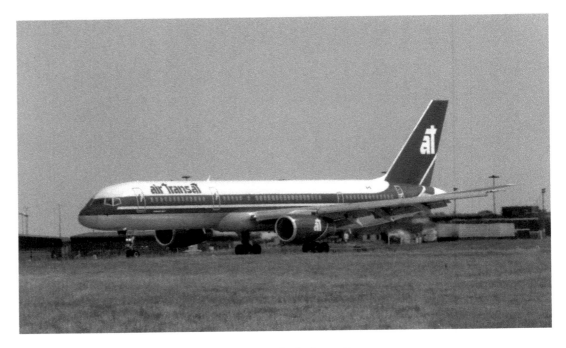

In the early 1990s, Air Transat also operated weekly flights to Toronto.

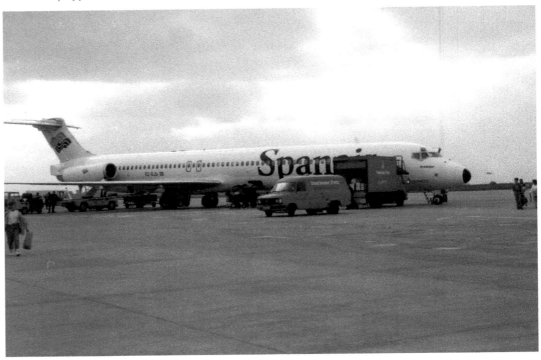

Passengers disembarking from a Spanair MD 80 after a flight from Palma.

A Leeds-based Short 360 of Capital Airlines taxiing.

A publicity photo of some of Capital's flight attendants. (Capital Airlines)

CAPITAL DESTINATIONS
CAPITAL FARES
CAPITAL SERVICE

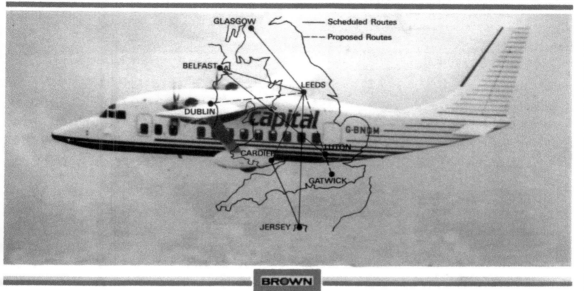

A member of Brown Group International PLC
Registered Office: Wharfedale House, Harrogate Road, Pool-in-Wharfedale, North Yorkshire LS21 2RZ. Registered in England No. 1740438

A timetable for Capital Airlines.

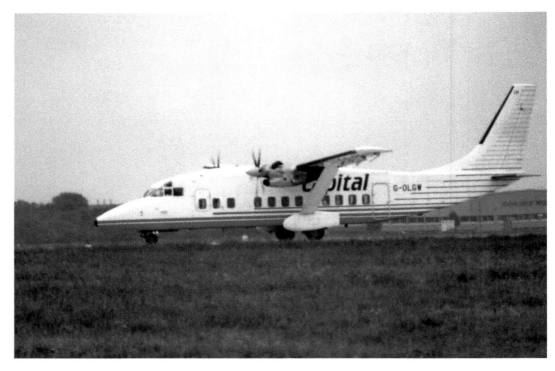

Capital operated six Short 360s until it ceased trading in June 1990.

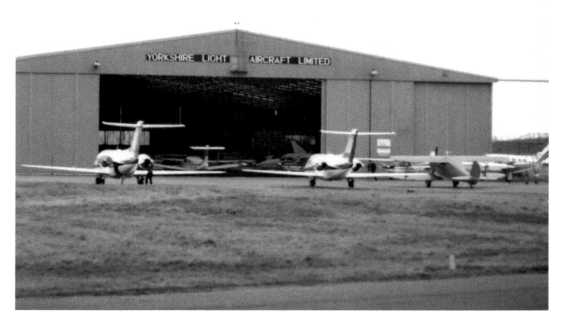

Yorkshire Light Aircraft hangar in the 1980s, complete with aircraft.

CHAPTER 8

The Nineties 1990–99

The nineties began with the airport still not having reached its millionth passenger nor given authorisation for twenty-four-hour opening, which it hoped would achieve by its sixtieth anniversary in 1991. Initially passenger figures for 1989 looked promising and the millionth passenger would be reached, but in the second half of the year passenger numbers declined. This was due mostly to reduction in charter flights – the total figure only reached 889,736 passengers, but it still was a record for Leeds Bradford Airport. Total aircraft movements for the same period were 56,827, nearly six thousand movements more than the previous year.

The nineties turned out to be a record decade for the airport both in finance and aircraft movements, but it was also the most expensive period to date. As, expected, the European Commission continued with its market unification proposals, which meant the disappearance of all duty-free trade between all EC countries in 1992. The majority of regional airports had to find alternative sources of income as revenues from duty-free goods were large. Several airports had introduced a system of renting shop spaces within the terminal building, which was quite successful in certain airports. Leeds Bradford Airport also benefited from de-regulation in 1992, which attracted a number of new businesses to the airport.

Another government directive was major changes in airport security, which meant the airport had to acquire new super-sensitive baggage X-ray machines capable of tracing most explosive substances.

With these alterations in mind there was a substantial amount of investment put into the airport including improvements to the terminal building, the construction of new domestic arrival and departure facilities with an extended restaurant as well as three floors of office space. One of the biggest blows to the airport in the nineties was the collapse of Leeds-based Capital Airlines in June 1990; although several attempts were made to restart the airline, none materialised. Capital Airlines' problems surfaced during 1989 when the airline inaugurated several new routes with insufficient aircraft to cover them. On numerous occasions flights were cancelled just to cover the newly acquired route. By the beginning of June 1990 the situation was critical and on 27 June all Capital fleet were ordered back to LBA. The following day the airline suspended all operations. The main reason for the action was that the parent company was in financial difficulties and was not prepared to continue financing the airline. Also, the airline was being investigated by the CAA for a number of irregularities. The collapse of Capital created shock waves, not only throughout the airline business, but also especially at Leeds

Bradford Airport, as the airline had provided a welcome boost to passenger movements in the eighties and generated a good source of revenue, which the airport could ill afford to lose.

Over the next few month there were several attempt to restart a Yorkshire-based regional airline, one of these being Yorkshire European Airways, which was equipped with two fourteen-seat, Brazilian-built Embraer Bandeirante commuter airliners. Yorkshire European's period was short lived as it announced on 22 November 1993 that it was ceasing operations. Two of its aircraft were impounded on 18 November because of unpaid lease money, resulting in passengers having to be transported to Teesside Airport for flights to Aberdeen. However, during the following year a new airline emerged on the scene, Knight Air, which took over YEA routes as well as adding new weekday services to the Isle of Man. Knight Air began operating from Leeds Bradford Airport on 31 June 1994 with services to Aberdeen, Cardiff, Southampton and the Isle of Man using two leased Embraer Bandeirante aircraft. A further two Bandeirante were acquired in 1995 to increase frequency to its four destinations.

Accidents involving carriers operating from LBA are very rare, but on 24 May 1995, shortly after taking off from the airport in appalling weather, Knight Air Bandeirante G-OEAA crashed near Duneswick, North Yorkshire. It seems that the pilot reported a failure in the aircraft's artificial horizon instrument and was advised by Leeds control to return to the airport. Flying in severe weather and lacking visual reference, the crew apparently tried to return to the airport. After a brave attempt by the pilot the aircraft crashed in some fields off the A61, ¼ mile from Harewood Bridge and four miles from the airport, with the loss of nine passengers and crew. As a show of respect the company flag in the foyer of the airport was lowered to half-mast on the day after the tragedy and the staff were allowed a period of mourning for the lost crew and passengers. As the result of the tragic accident the company wound down its airline operations and eventually ceased all scheduled operations, concentrating only on executive charters. Knight Air originated from Knightway Air Charter, which was formed in June 1982, based at LBA and Retford. The company operated both helicopters and fixed-wing aircraft on its executive charter services. In May 1992, the company was taken over by the Harrogate-based Lambson International group. The new owner's aims were to fill a gap left by Yorkshire European Airways and Capital and to develop the airline into the only Yorkshire-based airline. During the airline's first year of operations since forming in January 1994 it carried in excess of 70,000 passengers. Future plans before the fateful accident in 1995 were the acquisition of two eighteen-seat BAe Jetstream 31, which would increase the airline's capacity by some 30 per cent. Like so many small domestic airlines Knight Air found it rather difficult operating on third-level routes and competing with the larger companies.

The airline's scheduled routes to Aberdeen, Belfast, Southampton and the Isle of Man were taken over on 1 March 1996 by Manx Airlines Europe, which became known as British Regional Airlines and flew under the banner of British Airways Express. Manx Airlines leased the two Jetstreams from Knight Air for the new service from the airport.

Fortunately for the airport, by the end of the decade IT charters increased twofold and by 1998 several new destinations were added to the summer timetable. During 1991, Aspro Travel made its northern headquarters at the airport and the company's own airline, Inter European Airways became a common sight with at least one Boeing 737-300srs permanently based at Leeds Bradford. In November 1993, Aspro Holidays and Inter European Airways were taken

over by the giant Airtours Group. The Boeing 737 remained based at LBA still in IEA livery throughout the 1994 season, but was eventually to become one of Airtours' fleet.

It was also during 1994 that Mr Gordon Dennison retired as Airport Director and was replaced by Mr Bill Savage. Mr Savage's appointment occurred in the middle of a multi-million pound investment programme of improving and modernising the terminal as well as upgrading other airport facilities.

After a long meeting on 19 June 1994 Leeds City Council announced that they had awarded the airport its long-awaited permission to operate on a twenty-four-hour basis. As expected there were the usual objections. In the mid-nineties Mr Ed Anderson became the airport's Managing Director, replacing Mr Savage.

In 1996, after a long wait, the airport reached its one millionth passenger, a figure it had targeted for a number of years. The investment announced in the early nineties became a reality in 1997 when a new retail walkway and improved security screening zone was opened, followed in May 1998 by additional check-in desks, the new international departure lounge and air bridges, which were essential in a modern airport. Since 1994, passenger through-flow through the airport had increased by 75 per cent, and to facilitate this increase, a total of twenty-six modern check-in desks were installed to minimise passenger delays.

A new international departure lounge was opened that was three times larger than the old one and capable of accommodating 850 passengers. A new £350,000 air bridge was built to allow passengers access to aircraft directly from the terminal building, avoiding the usual walk across the apron. Further air bridges were added at a later date during the next phase of modernisation. The completion of the first phase of development represented over £4 million of investment since 1995.

As the result of an upsurge in holiday flights in the mid-nineties Monarch Airways and Air Europe based a Boeing 737-300srs each at the airport to cope with the demand. Throughout the nineties IT flights continued to be operated from Leeds Bradford Airport to all the favourite destinations in the Mediterranean region and Tenerife.

Scheduled flight destinations remained more or less the same despite the demise of Capital, Yorkshire European and Knight Air. Loganair took over the Leeds–Glasgow, Jersey European the flights to Belfast City, the Belgian commuter airline DLT the twice-daily flights to Brussels. British Airways Express (formerly City Flyer Express) took over the Gatwick flights.

However, during 1994, Manx Airlines, which had taken over all Loganair schedule flights outside Scotland, increased their frequencies on their flights to Glasgow from Leeds and for the first time introduced the Jetstream J41 and the larger BAe ATP aircraft to the airport. British Midland continued to operate the London Heathrow, Amsterdam and Paris flights. On 5 May 1998, British Midland introduced jet aircraft for the first time on its Paris flights. The seventy-four-seat Fokker 70 replaced the thirty-four-seat Saab 340 turbo prop. The new jet cut the journey time by thirty minutes, enabling the airline to increase its frequency to three times a day. Air UK introduced the larger Fokker F50s on its services out of LBA, replacing the ageing F27s.

During the nineties the airport witnessed a decade of growth with an increase in passenger numbers and aircraft movements, a twenty-four-hour operating licence, new investment and much-needed expansion, setting the airport on a sound foundation as it entered a new millennium.

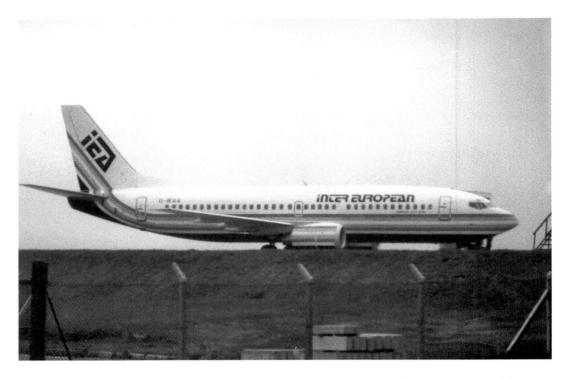

A Boeing 737-300 of Inter European Airways is seen here at Leeds Bradford being operated by Aspro Travel.

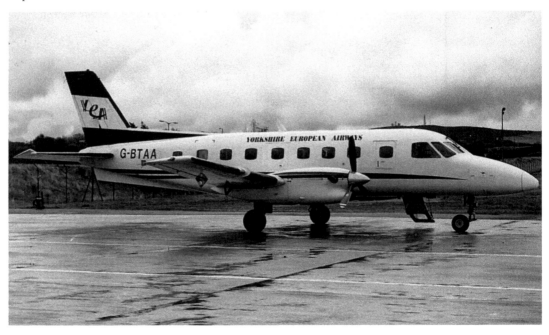

Following the collapse of Capital Airlines, Yorkshire European Airways took over some of its routes. This photo shows one of the airline's Embraer Bandeirante aircraft, G-BTAA.

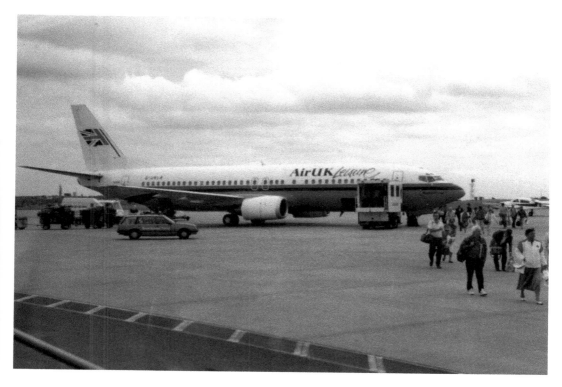

Passengers disembarking from an Air UK Leisure flight.

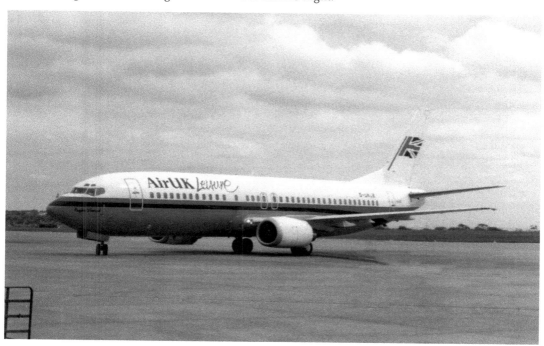

A Boeing 737-300 of Air UK taxiing towards the terminal.

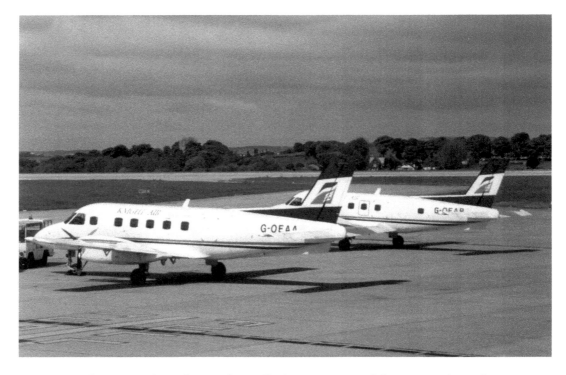

In 1994, Knight Air was formed at Leeds Bradford Airport. Two of the company's Bandeirante aircraft can be seen in this photo.

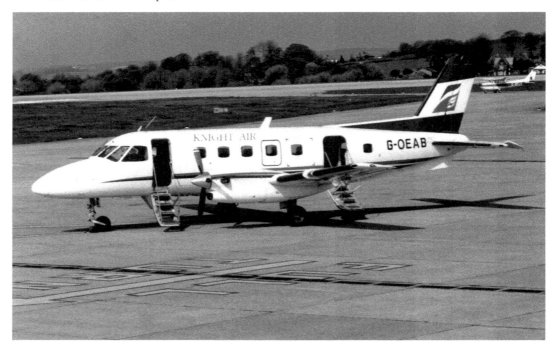

Knight Air Bandeirante G-BEAB is seen here at the airport.

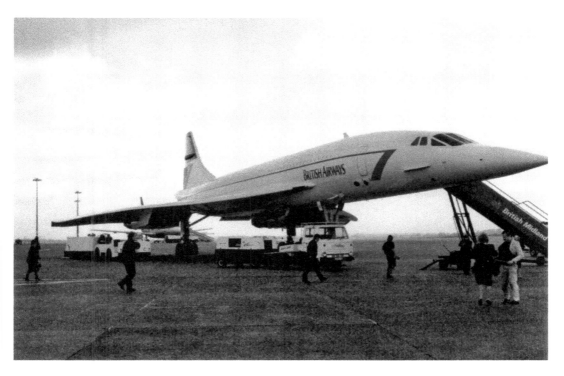

Concorde being prepared for a flight.

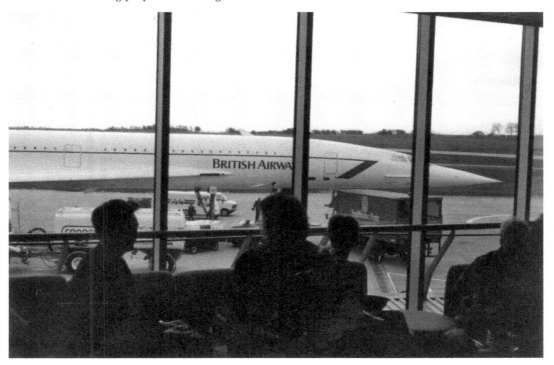

Concorde, viewed from the restaurant.

British Airways Concorde G-BOAA taking off, April 1993.

An Airbus A320 of Air 2000 landing at Leeds Bradford Airport, June 1994.

A Short 339 of British Airways Express at the airport in May 1994.

Air UK used Fokker F50s to replace the older F27s on domestic flights from Leeds Bradford Airport.

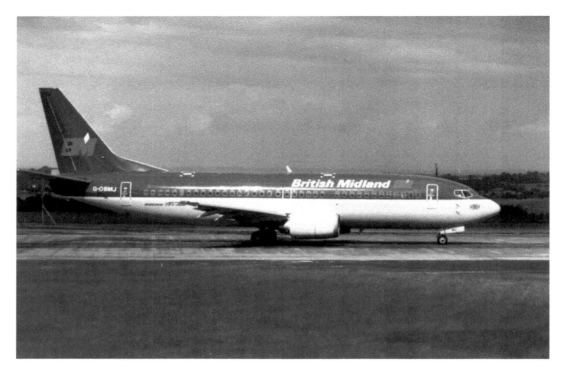

During the 1990s, British Midland used Boeing 737-300s on flights to Heathrow.

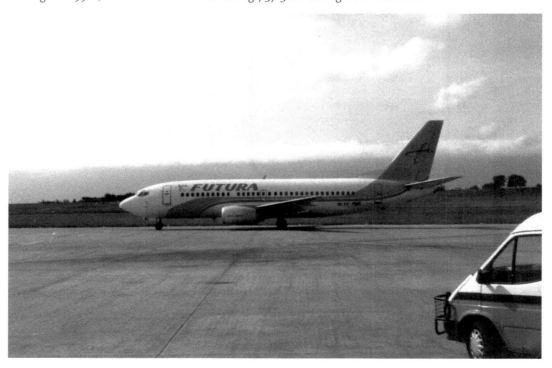

Futura was another Spanish airline that operated charters from Leeds Bradford Airport.

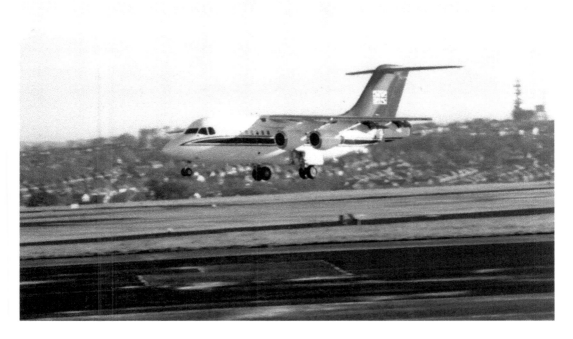

RAF aircraft of the Queen's Flight were regular visitors to the airport. Here a BaE 146 can be seen landing.

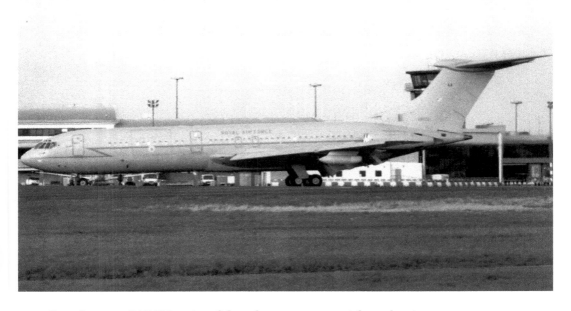

Over the years RAF VC10 aircraft have been a common sight at the airport.

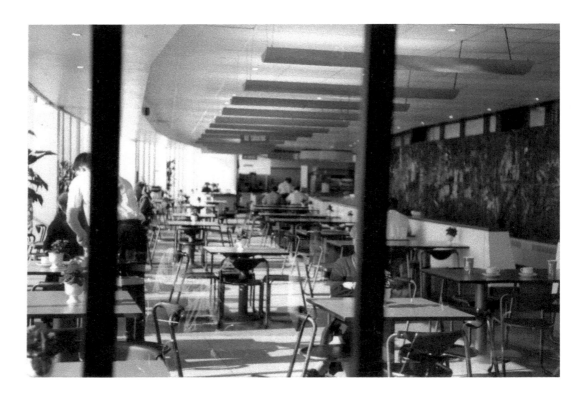

The old dining area with Philippa Threfall mural on the back wall.

CHAPTER 9

A New Century and a New Future

Entering a new decade and a new century was a milestone in the airport's history. Major improvements and redevelopment had taken place, new airlines emerged offering the people of Yorkshire new destinations at a low cost, and half-way through the decade the airport came under new ownership with a multi-million-pound investment.

In 2000/1 the next phase of the investment announced in the nineties became operational, with the upgraded Hold Baggage Screening area, the new arrival walkway and a new domestic arrivals area complete with a new baggage carousel. In December 2001 the second air bridge came into use, which has become a must at a modern airport.

The expansion to the retail infrastructure continued throughout the decade including a fast food outlet, a wine bar and food village in July 2003, followed in July 2005 by the opening of a bakery, a drugstore outlet and the Yorkshire Hero pub, which replaced the lounge bar, all part of the £5 million redevelopment package. In 2001 the airport recorded 66,000 movements accounting for over 1.5 million passengers and despite not attracting any freight operations to Leeds Bradford International some 7,000 tonnes of cargo was transported through the airport.

There had been a lull of some ten years before a new Leeds Bradford-based airline emerged. The Dart Group, owners of the all-cargo airline Channel Express, set up a new low-cost passenger airline in October 2002 to be based at Leeds Bradford. The Yorkshire airport was chosen as it had not attracted any of the other low-cost airlines and the company felt there was a sufficient population to warrant a low-cost operator. The new airline was Jet2.com and was launched on 12 February 2003 with a twice-daily Leeds–Amsterdam service. Within weeks further routes to Alicante, Barcelona, Malaga, Palma, Nice and Bergamo were introduced using Boeing 737-300srs. During the first year of operation the airline carried more than 360,000 passengers. The airline route network continued to expand through the years and has become one of the main low-cost airlines operating from British airports.

By December 2003, the airport had handled well over two million passengers. The target of two million was reached a year earlier than predicted. For some years Leeds Bradford Airport had lacked sufficient check-in desks to deal with the ever-increasing travellers, especially during the peak Summer season, so sixteen new check-in desks were added in Hall B bringing the total at the airport to forty-two. In 2005, at the height of the terrorist activities in the United Kingdom when all airports became targets for terrorism, Leeds Bradford did not escape the turmoil. The airport received its first bomb threat; luckily, it was just a hoax but it caused mayhem at the

airport with flights cancelled and others diverted. In May there was further disruption at the airport when a twin-engine aircraft overshot the runway causing cancellation and diversions once again. The airport returned to normal operations the following day. In August, another emergency landing took place at LBA, but did not cause too much chaos. On 20 August, a Leeds-based aircraft was involved in another emergency landing.

Flybe (previously known as British European) had operated flights from Leeds Bradford Airport since 1991, but on 1 December 2005 the airline launched low-cost flights to France from LBA and within a month the airline's passenger numbers soared. One of the new airlines to operate scheduled services from LBA was the Irish airline Aer Arann with flights to Galway.

While most airlines had increased frequency on their schedule flights and introduced new routes from the airport, bmi (British Midland International) announced on 8 February 2006 the scrapping of its scheduled flights to Jersey. However, Thomsonfly was able to step in by offering passengers free parking at Leeds Bradford Airport.

2006 was a record year for the airport as nearly 2.8 million passengers passed through the terminal building, a massive 73 per cent increase in just six years, which was twice the number in 1997 (a mere 1.2 million). This figure was helped by the low-cost airline Jet2.com, which introduced new scheduled services from the airport. In the month of July, 300,000 passengers passed through the airport's terminal, making it the busiest month on record. These figures were reached by nine scheduled airlines and over forty tour operators flying out of LBAI to over sixty-five British and International destinations.

For some years Leeds Bradford had two runways in use: 14/32 for all commercial flights and 09/27 (or 10/28 as it was known for many years) for private flying. Due to acute aircraft parking space at the airport, runway 09/27 was closed for flying on 6 October 2005 and was redeveloped as a taxiway with additional apron parking area. By the middle of the decade most of the airports in the United Kingdom had been transferred from council ownership to private and multi-national companies. After a number of long and arduous meetings regarding the privatisation of the airport all the controlling councils of Bradford, Leeds, Wakefield, Calderdale and Kirklees agreed to sell the airport to the private sector. On 6 October 2006 the airport celebrated its seventy-fifth birthday.

Several multi-national companies and investment firms showed interest in the airport and by the end of the year the bids began to materialise. The first announced bid was from an Ulster firm followed by a bid from the Spanish Abertis company. However, the controlling councils' price tag for the airport was around £150 million. The final short-listed bidders were Balfour Beatty with a £140 million bid, the Spanish Abertis with an unannounced bid and Bridgepoint Capital with a £145.5 million bid. On 4 March 2007, it was announced that the Bridgepoint offer was the preferred bid and finally on 3 May it was confirmed that the sale had been agreed, the final price being £145.5 million. Bridgepoint won the bid mostly on two accounts; first it was the highest bidder, and secondly it had ambitious expansion plans for the airport by promising to invest at least £70 million in improving passenger and retail infrastructure.

At the end of 2007 the airport received a very damning report regarding noise pollution and it was classed as one of the eighteen worst airport polluters in the UK. The airport was instructed to cut noise pollution to meet EU environment policy and was given notice to produce a plan

to reduce noise levels before their next assessment in five years. In that time the airport hoped that most airlines would dispose of their older type of aircraft like Boeing 737 srs 200, Boeing 727 and of course Tupolev TU154s.

Thankfully, air emergencies are fairly rare at Leeds Bradford Airport but when they do occur, the full weight of the emergency services springs into action with the help of the local fire service. On 3 March 2008, Austrian Airlines Fokker F100 on the Innsbruck to Leeds flight with 103 passengers aboard reported an engine failure. Twelve fire tenders from the airport and vicinity were waiting for the flight, but, fortunately, the aircraft landed safely on one engine. Another emergency took place on the evening of 23 May when fire-fighters from a number of local stations converged on the airport to deal with smoke coming from a Jet2.com Boeing 737. All the passengers were evacuated from the aircraft, but the smoke was caused by an overheating undercarriage.

It was announced on 26 June 2008 that Mr Ed Anderson was appointed the new executive chairman of the Airport Operations Association. Mr Anderson was the managing director of LBA between 1997 and 2007. At the beginning of July, LBAI appointed a new chairman, Mr Alan Lewis, who had been the deputy chairman under Sir Graham Hall, who had resigned. Mr Lewis was an advisory partner of Bridgepoint and a former board member of Birmingham Airport.

In April 2008, Mr Tony Hallwood was appointed Commercial and Aviation Development Director and has been one of the main forces behind the more recent development and drive in promoting the airport internationally. During 2008, several new routes were introduced, offering travellers a variety of destinations, some of which were completely new to Leeds Bradford. In June 2008, Leeds-based Jet2.com airways launched a weekly service to Egypt, soon to become a popular tourist destination in the Arabic world.

In August 2008 the Yorkshire Air Ambulance moved its base to Leeds Bradford International Airport from Sheffield City Airport, which eventually closed.

The airline, Jet2.com, can be classed as one of the most successful British airlines of the decade; it has continued to expand with an ever-growing route network. Today, the airline has hubs at Manchester and Belfast with its main hub at LBAI and regularly operates from Blackpool, Edinburgh and Newcastle. Passenger figures carried by the airline have increased annually from a meagre beginning in 2003 of 604,563 to nearly 4 million in 2007 – a load factor of 73.6 per cent. During November and December 2008, Jet2.com operated a series of four special charter direct flights from Leeds Bradford to New York Newark using Boeing 757s.

On 12 December 2008 the airport was hit by severe snow and ice and all the morning flights were cancelled or delayed. However, the airport was reopened in the afternoon but did not fully return to normality until the next day. On 22 January 2009, plans were put before the council by Bridgepoint for expansion of the terminal building. The plan is part of the £70 million scheme to increase passenger numbers to around 5 million a year by 2013. The master plan includes a two-storey extension costing about £28 million, a new passenger screening zone, a new departure lounge, an improved baggage reclaim hall and a further £450,000 spent on improving access roads to the airport. Emphasis was also put on a feasibility study exploring a possible light railway link to the airport. Being in a rather isolated position the airport has always suffered from poor transport links to populated areas.

In early 2009, British Midland was taken over by the German airline Lufthansa and inevitably there was reorganisation of a number of routes. In March, the airline ceased its service to London Heathrow, which it had operated since 1997. It was not because of passenger numbers, but rather the airline wanted the valuable landing slots at Heathrow for other flights. However, bmi had considered reducing its flights from Leeds Bradford the previous year due to an increase in landing fees as airport charges are the biggest percentage of operating costs of any short-haul airline.

Further Jet2.com expansion included a twice-weekly service from LBA to Albert-Picardie in France in May/June 2009.

Ryanair had operated flights from LBA since 1989, but in March 2010 announced that the airport would be its thirty-fourth base with two aircraft permanently based there. In September 2010, the multi-million-pound redevelopment of the airport forecourt was completed. It was in two phases; Phase 1, improvement of the bus stops with new drop-off and pick-up points for passengers. Phase 2, improvement of the bus shelters with timetable screens and pedestrian walkways. On 19 September, Eastern Airways acquired Air Southwest (which kept its separate identity), whose fifty-seat Dash 8-300 turbo props operated scheduled services to Bristol, Plymouth and Newquay. However, Air Southwest ceased operations on 30 September 2011 as Plymouth Airport closed.

In October 2010, Easyjet introduced a number of winter flights from the airport starting with a five-times-a-week schedule to Geneva, taking advantage of the growing appeal of skiing holidays. LBA-based Jet 2 announced a lucrative 2010 Summer season, flying 2.8 million passengers from Leeds Bradford, East Midlands and Blackpool with over a million passengers flown from Leeds Bradford alone.

In a report published by the CAA, Leeds Bradford International was accredited as one of the top fifteen fastest-growing airports in the UK. In July 2010, the airport reported an 11 per cent year-on-year growth handling a total of 352,175 passengers compared to 318,549 passengers during the same month in 2009. The year ended with adverse weather conditions which closed the airport, causing disruptions to flight schedules. Like most of the other UK airports its snow ploughs and de-icing vehicles battled with heavy snow falls and low temperatures. As one person remarked, being on a hill the airport has always had to contend with bad weather and snow but this year had been the worst ever.

2011 was yet another important and successful year with the planned improvements and restructuring given the go-ahead. The biggest disruption in 2011 was in May when the ash cloud from an Icelandic volcano disrupted flights in Scotland and Northern England. Several in- and outgoing flights were cancelled.

The airlines Easyjet, Jet2.com and Ryanair announced additional destinations and increased frequencies on the existing ones. Ryanair introduced flights to the Eastern European destinations of Riga in Latvia and Kaunas in Lithuania.

Leeds Bradford International Airport's future looks certain thanks to its new ownership and a new influx of investment, perhaps something that was missing throughout its turbulent existence. The airport sadly has witnessed several false hopes with emerging new airlines, new routes and enthusiastic new leadership, so one hopes that this phase in its existence is the beginning of a new future capable of competing with any airport in the United Kingdom and it being the centre of commercial aviation in the north of England as predicted by Major Ackroyd in 1935.

The terminal and control tower in 2005. (© David Benbennick)

Inside the terminal at Leeds Bradford Airport on 9 May 2005. (© David Benbennick)

Aer Arann ATR72 at Leeds Bradford in 2007. The latest models of ATR72 are amongst the world's most environmentally friendly aircraft. Aer Arann started life in 1970, serving the Aran islands but has grown to become Ireland's regional airline. (© 54North)

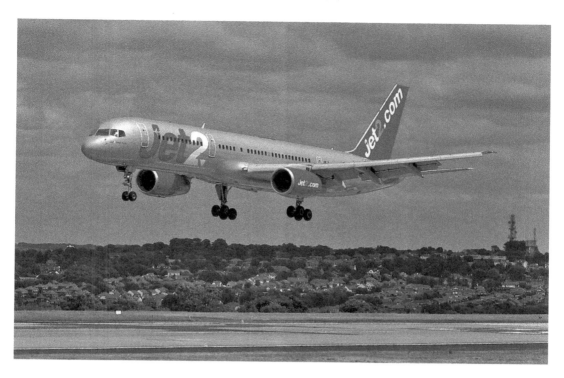

A Jet2.com Boeing 757-200 lands at the airport in July 2008. (© 54North)

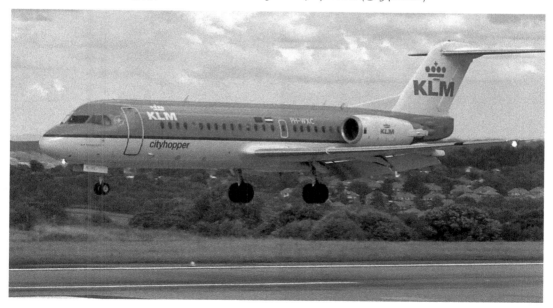

A KLM Cityhopper Fokker 70, PH-WXC, lands at Leeds Bradford in July 2008. The Fokker was built in 1995, a year after the type was introduced. Forty-seven were built before Fokker went into bankruptcy. (© 54North)

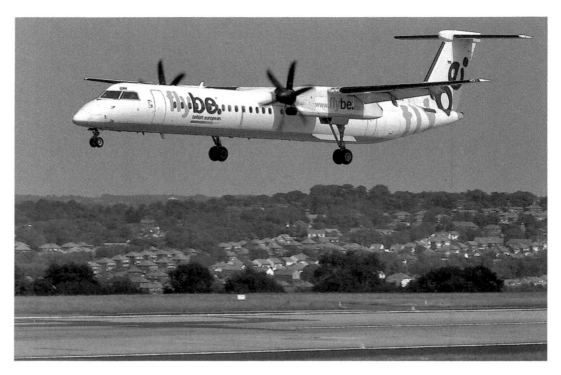

A Flybe Bombardier Dash 8 lands at Leeds Bradford in July 2008. The design of the Dash 8 dates from 1984, with a De Havilland Canada design. Over 1,000 Dash 8s have been built. (© 54North)

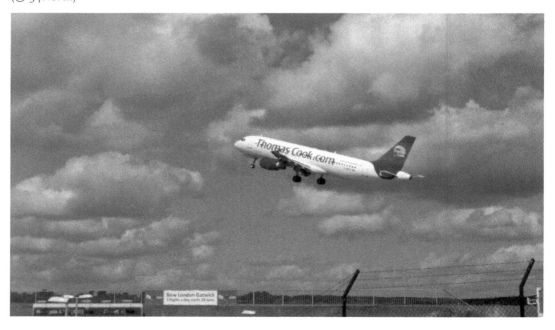

A Thomas Cook Airlines Airbus A380 taking off via the main runway on 22 August 2009. (© Mtaylor848)

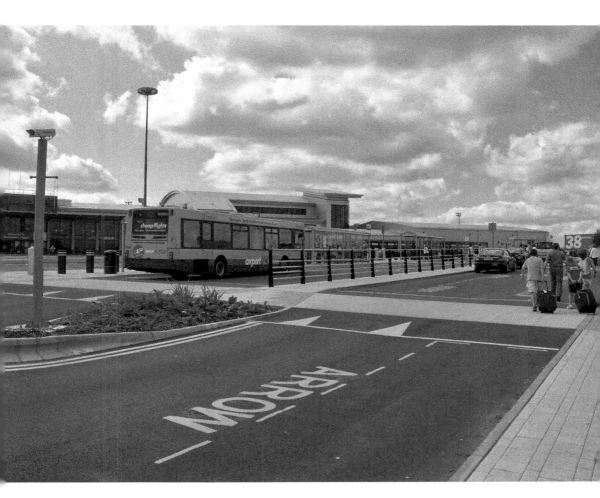

The bus interchange with a Volvo B10BLE on the Airport Xpress route 767 on 22 August 2009. (© Mtaylor848)

Jet2.com is based at Leeds Bradford, offering cheap flights. Three of their planes and a bmi jet are visible in this shot taken on 22 August 2009. (© Mtaylor848)

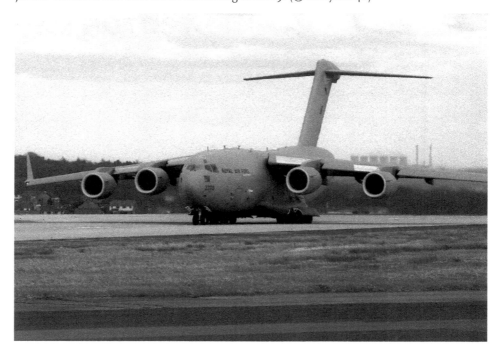

RAF Boeing C17 on troop movement.

G-CELE, one of Jet2.com's Boeing 737s is shown on the apron on 13 September 2009. The aircraft, named *Jet2 Belfast*, was originally built for Monarch Airlines and spent time with Jersey Express before arriving in the Jet2 fleet. (© Ardfern)

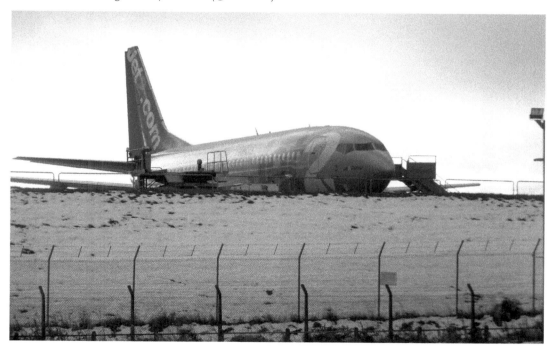

A Jet2.com Boeing 737 in the snow on 24 December 2009. (© Mtaylor848)

Leeds Bradford in the snow on 27 December 2009. (© Mtaylor848)

The new modern check-in desks.

The check-in desks fully utilised on a busy day.

The old duty-free shop and departure lounge.

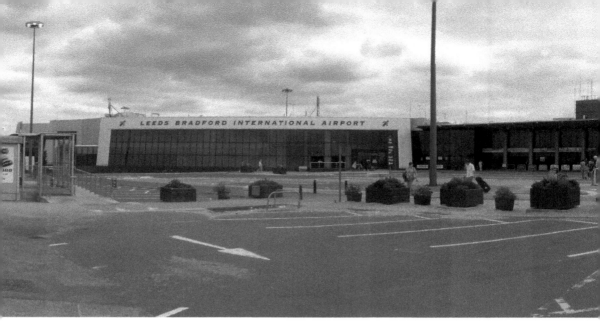

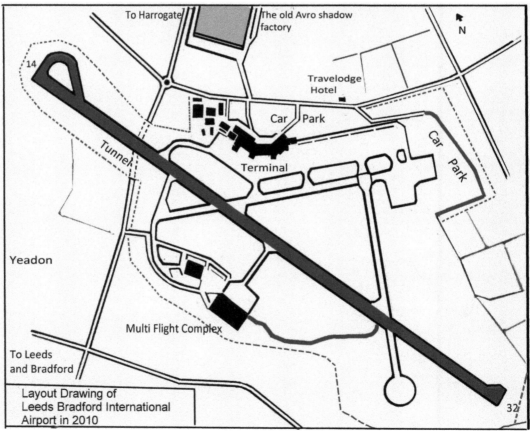

Layout plan of the airport, 2010.

A panoramic shot of the front of the terminal on 24 July 2010. (© Mtaylor848)

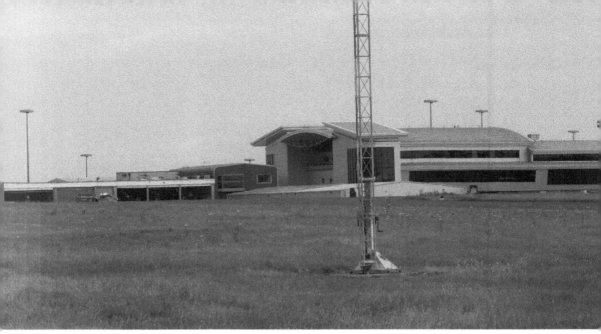

The Multiflight hanger on the south side of the airport. Multiflight is a private flying school, but also provides air charter services as well as executive aircraft handling and maintenance. (© Mtaylor848)

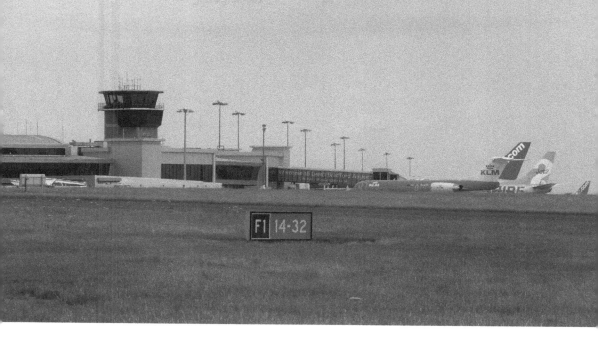

Jet2.com and KLM aircraft are at the terminal gates in this panoramic view taken from airside on 24 July 2010. (© Mtaylor848)

A Robinson R22 Beta helicopter takes off from Leeds Bradford in 2010. The airport is also base for the West Yorkshire Air Ambulance. (© Mtaylor848)

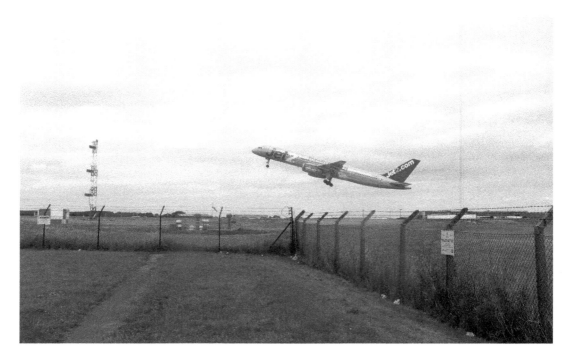

G-LSAG, a Jet2.com Boeing 757-200, takes off on 24 July 2010. (© Mtaylor848)

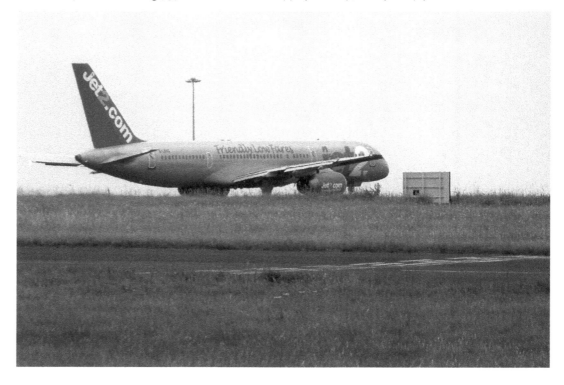

Taxiing ready for take-off is G-LSAG, a Boeing 757-200. (© Mtaylor848)

The bus interchange with the 757 service to Leeds and a bus for flight crews at the stances in July 2010. (© Mtaylor848)

A Robinson R-44 Clipper II of Northern Heli Charters on 24 July 2010. (© Mtaylor848)

A Piper PA28-161, built in 1985, is shown close to the Multiflight hanger on 24 July 2010. (© Mtaylor848)

The jet2.com offices. The company flies from Northern England, Soctland and Ireland to various European destinations. (© Mtaylor848)

Tailfins on 24 July 2010. (© Mtaylor848)

Jet2.com's Boeing 737-300 G-CELB on 24 July 2010. (© Mtaylor848)

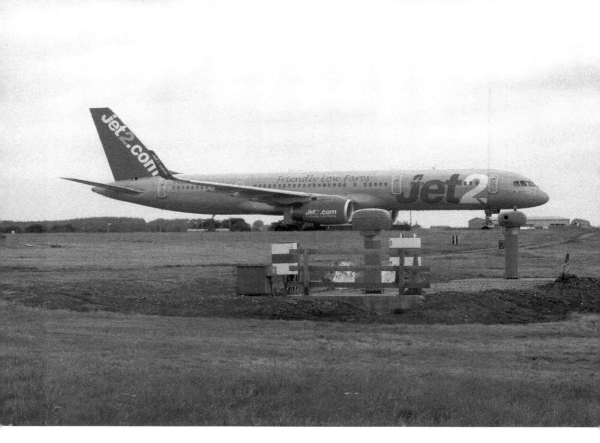

Just landed is Jet2.com's Boeing 757-200 G-LSAB, shown here heading for the terminal building. (© Mtaylor848)

Multiflight made its base at Leeds-Bradford. (Multiflight)

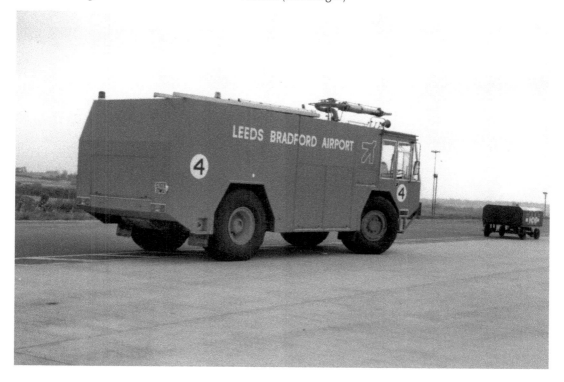

One of the airport's fire tenders in the 1980s.

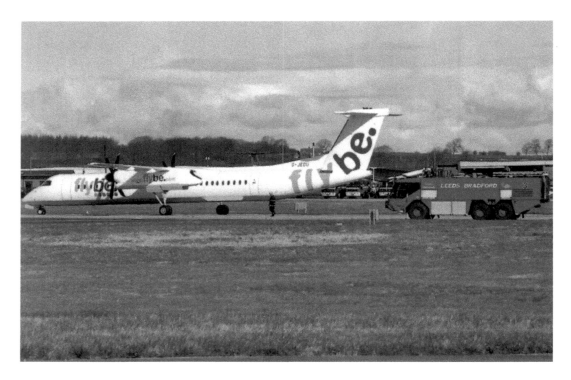

Today, the airport has more up-to-date tenders. This one is attending a minor incident involving a Flybe Dash 8 aircraft.

Air Malta still operates holiday flights to Malta; this view shows one of the airline's Airbus A319s.

The airport has always suffered from severe winter weather. This view shows an aircraft being deiiced.

An unusual visitor to the airport was a Corsair Boeing 747SP jumbo jet (shortened version).

A bmi Airbus A319 about to take off.

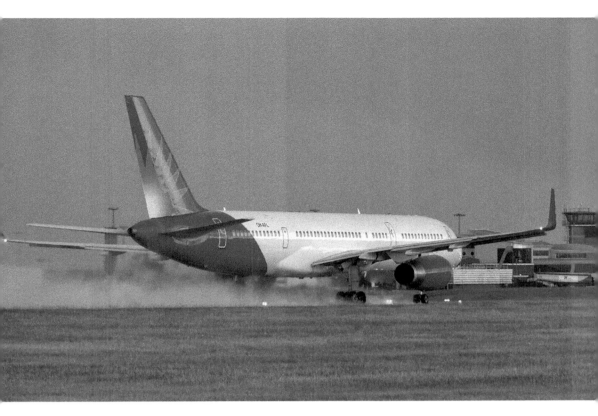

An Air Finland Boeing 757-204, OH-AFL, landing at Leeds Bradford. This aircraft was delivered to Air Finland in March 2011. Previously, it had served with Britannia Airways and Thomsonfly. (© Mark Winterbourne (http://www.flickr.com/people/49775211@N03))

List of Airlines Associated with LBA

Scheduled Airlines

Aer Arran

This Irish-based airline had been operating services between Irish towns and cities since 1970. First scheduled service between LBA and Cork and Galway was introduced in June 2006.

Aer Lingus

Began scheduled flights between Dublin and Leeds in 1960, but these were discontinued in late nineties.

Air Southwest

Air Southwest was formed on 15 January 2003, based at Plymouth City Airport, and adopted its present name on 3 June 2003. The airline operates services between LBA and Bristol, Newquay and Plymouth. The fleet includes five Bombardier Dash 8 airliners. The airline was taken over by Eastern Airways in December 2010, but kept its separate identity. Air Southwest ceased operations on 30 September 2011 as Plymouth Airport closed.

Air UK

Air UK was formed on 1 January 1980, when Air Anglia, British Island Airways, Air West and Air Wales merged into a single entity. The airline operated several schedule flights to various destinations in the UK and to Amsterdam. Over the years their route network from LBA has been reduced drastically and by 2000 the airline only served Amsterdam, but within five years that too was dropped.

BKS/Northeast

BKS's origins went back to 12 October 1951 when the airline was formed at Southend, but it was not until 7 February 1952 that the new company was registered. The airline's association with the north of England began in March 1953 with charter flights from Newcastle and West Hartlepool. It was not until 1956 that BKS began services from Leeds Bradford and throughout the decade continued to build up its network from the airport. In 1970 BKS changed its name to Northeast and eventually became part of British Airways.

British Midland/bmi

As Derby Airways, this line began services to Leeds in the early sixties with a Derby–Leeds–Glasgow service. In 1997, under the guise of British Midland, they acquired from British Airways the London Heathrow service, which they have kept since, but in March 2009 they ceased their London Heathrow service. In 2009, bmi was taken over by the German airline, Lufthansa.

Capital Airlines

Capital commenced operation at Leeds Bradford Airport during 1983 as Brown Air. Over the next five years the airline continued to expand its route network, connecting Leeds to various destinations in the UK and Ireland. However, in June 1990, Capital Airlines ceased operations.

Dan-Air

Dan-Air began operations on 21 May 1953 under Davies and Newman, from whom the name derived. Initially the company was involved with ad hoc charters mainly from its base at Blackbushe, but in 1956 introduced its first scheduled service to Jersey. The airline's first association with Leeds Bradford was in the seventies when it took over the Glasgow service from British Midlands. Over the next decade its route network and aircraft fleet grew and leading up to its collapse it operated the Channel Islands service from the airport as well as a number of IT charters. Due to financial problems the airline ceased operations on 23 October 1992 with most of its routes taken over by British Airways.

Eastern Airways

Based at Humberside Airport, Eastern Airways began operations in December 1997. Today the airline operates a fleet of twenty-three Jetstream 41s and eight SAAB 2000 airliners. Eastern connects LBA with Aberdeen, Inverness, and Southampton.

Loganair

When Capital Airlines ceased trading in June 1990 a considerable number of prestige routes became available, one being the Glasgow service. On 28 October 1990, the Scottish airline Loganair was awarded a permanent licence for the route. Soon afterwards the airline had some financial problems and the Leeds–Glasgow route was handed over to its sister airline Manx Airways. In September 1994, Loganair was taken over by British Airways Express.

Jersey European/Flybe

This airline appeared for the first time at Leeds Bradford on 25 March 1991 with three flights daily to Belfast City using their Fokker F27. Today, the airline connects LBA to Aberdeen, Belfast City, Bergerac, Exeter and Southampton. Jersey European was formed in November 1979 after the takeover of the Jersey-based Intra Airways operations. In November 1983, the airline was acquired by the Walker Steel Group, which already owned Spacegrand Aviation and the two airlines were amalgamated on 26 October 1985. On 8 May 2000, the airline changed its name to British European with the re-branding completed by 2001. Responding to changing market conditions the company decided to redefine the airline between the major scheduled carriers

and the low-fare carriers. This meant another re-branding and in July 2002 the airline was re-launched as Flybe.

Knight Air

This airline could trace its origins back to 1982 when it traded as Knightway Air Charter, operating an air taxi and business charters from Leeds Bradford Airport. With the collapse of Yorkshire European Airways in 1992 the company was granted a licence to operate services to Aberdeen, Southampton and the Isle of Man. The airline took over the two Bandeirante impounded at the airport. The airline then adopted a new name, Knight Air. In May 1992 Knight Air was taken over by the Harrogate-based Lambson International Group, which was able to inject further capital into the newly started airline. However, scheduled services did not begin until January 1994 with a twice-daily service to Aberdeen. Other routes to Southampton, Belfast and Teesside followed. In the first year the airline carried over 10,000 passengers and a further two Bandeirante aircraft were acquired. However, tragedy struck on 24 May 1995 when G-DEEA crashed in bad weather some four miles from the airport with no survivors. In April the company announced that it was withdrawing from the scheduled market, concentrating instead on its aircraft maintenance facilities.

Manx Airlines

Manx originally began operations on 1 November 1982 when British Midland and the British & Commonwealth Shipping Group, through Air UK, formed an airline to link the Isle of Man with the mainland. The airline, in its various guises and different owners, has always connected LBA with the Isle of Man.

Manx2.com

Manx2.com was formed on 15 May 2006 to provide year-round services between Isle of Man and mainline Britain and Ireland. The first scheduled service began on 15 July 2006 to Blackpool and Belfast International using two Czech-built Let L41 twin turbo props. As the airline expanded, two Fairchild Metroliners and two Dornier 228s were acquired. Today, the airline serves Leeds Bradford with a twice-daily service to the Isle of Man.

North South Airlines

Registered as an airline on 29 May 1959 by Lord Calthorop, founder and managing director of Overseas Transport Company and based at Yeadon. Most of the airline's operations were ad hoc charters from Yeadon and other airports to Jersey and the Continent. The airline ceased operations on 12 March 1967.

Jet2.com

A subsidiary of the Dart Group PLC, Jet2.com is an aviation service and distribution group. Airline interest of the group was Channel Express, primarily a freight and passenger charter service. Jet2.com was set up in October 2002 as a low-cost carrier operating in the north of England, with hub bases at both LBA and Manchester. The new airline was launched on 12 February 2002 with a twice-daily service to Amsterdam from Leeds. In 2006, Channel Express

operational headquarters moved from Bournemouth to Leeds Bradford Airport. The airline has a fleet of twenty-one Boeing 737-300s and eight Boeing 757s. Today, the airline operates flights from Leeds Bradford to Amsterdam, Belfast International, Dusseldorf, Geneva, Krakow, Milan, Nice, Paris, Prague, Rome, Salzburg and the Mediterranean holiday destinations.

KLM

For many years, KLM, the Dutch national carrier, and Air UK had a close association, which eventually lead to KLM taking a 45 per cent share in the British airline and on 1 July 1997 the two companies were integrated, with Air UK becoming a wholly owned subsidiary of KLM. On 30 January 1998, the airline was re-branded and traded as KLM UK. In 2009, the airline's commuter carrier KLM Cityhopper operated five daily services to Amsterdam from LBIA.

Plusair

Formed in 2009 as a virtual airline offering scheduled services and passenger charters to domestic and European destinations from its hub at Leeds Bradford International.

Ryanair

The independent Irish airline was the leader in the introduction of low-priced economy scheduled services between points in Ireland and the United Kingdom. Ryanair's first appearance at Leeds Bradford was in 1989 with the seasonal flights to Connaught in Ireland. Today, it operates three flights daily between LBA and Dublin.

Sabena/Delta

The Belgian national carrier has served Leeds Bradford since 1990 with regular daily flights to Brussels until early 2000. Due to financial crises during 2000 the airline ceased operations and in 2001 filed for bankruptcy. In 2009, the Brussels flights were operated by bmi.

Severn Airways

Formed in August 1973 by a group of ex-BAC and Bristol businessmen, in December 1974 it was granted licences to operate a number of scheduled services from Bristol. The inaugural service between Cardiff, Bristol and Leeds took place on 18 March 1975 using a de Havilland Dove. The airline ceased to operate on 9 July 1975 because of the lack of acquiring new investment.

Thomsonfly

A budget/low-fare airline of Britannia Airways. It began operating low-fare flights from East Midlands Airport on 31 March 2004. Since then the airline has extended its route network and flies from most UK airports. Today, the airline flies both Inclusive Tour charters and low-fare flights from Leeds Bradford.

Wardair

Wardair began operations as a bush airline in Canada in 1946. Over the years it grew to by one of Canada's major carriers. The first transatlantic services from Leeds began in the summer of

1986 and continued until 1988 when the airline was taken over by W. A. Corporation. Sadly, the airline has ceased operations.

Yorkshire European Airways

This airline was formed by two Yorkshire businessmen, Mr Paul Whitaker and Mr Brian Beesley, to fill a gap left by the collapse of Capital in June 1990. Initial the paper airline was called Executive Airlines Ltd but changed its name to Yorkshire European Airways. Services began in the summer of 1992 to Aberdeen and Southampton, followed within weeks by twice-daily services to Belfast. Within a year, flights to the Isle of Man were added to the airline route network. Due to unpaid leases on the aircraft both were impounded at the airport and the airline ceased operations. The airline's fleet included two Embraer EM 110 Bandeirante.

Inclusive Tour Airlines

Over the years, a number of charter airlines have operated IT (Inclusive Tours) holiday flights from Leeds Bradford International, whether to the Isle of Man and the Channel Islands or to the Mediterranean area or even to destinations further afield. Some airlines only made a brief appearance at the airport for one season only, while others became regular visitors. The list is as follows:

Adria

Charters to Yugoslavia on behalf of Yugotours. Ceased operations in 1993.

Aerotime

A French airline that operated IT charters during the summer of 1989.

Air Europa

Set up by the ILG Travel group with flights to the Mediterranean. When ILG ceased operationa the Spanish airline continued to operate through its Spanish backers. The airline was taken over by the Globalia Corp and today it is the third largest airline in Spain.

Air Europe

Wholly owned by ILG Travel, in April 1991 the airline ceased operations.

Air Malta

Operates flights to Malta.

Air 2000

Began operation in 1987 providing charters all over the world.

Airtours International

Formed in 1990, it has IT flights to destinations throughout the world. In 1993, Airtours International took over the Aspro Travel Group, which included Inter European Airways.

Air Transat
A Canadian charter airline based at Montreal; operated the Canadian services from LBA during 1989.

Air UK Leisure
A charter operation division of Air UK.

Aviogenex
Another Yugoslavian charter airline, ,which ceased operations due to the civil war in Yugoslavia.

Balkan
Operated Tupolev TU134 flights from LBA to Bulgaria.

Britannia Airways
Began trading as Euravia Ltd on 1 December 1961. With the acquisition of Bristol Britannia aircraft the airline changed its name to Britannia Airways. In 1965, the airline was taken over by the Thomson Organisation, which also took over some travel companies. Britannia Airways made its first appearance at Leeds Bradford in 1976 and for the following decades became the main charter carrier at the airport.

British Airways subsidiary **British Airtours**
Operated IT charters from the airport during the early eighties.

British Island Airways
Operated charters from LBA mainly to Minorca during the eighties.

First Choice
Commenced operation as Air 2000 with flights to holiday destinations in the Mediterranean basin, Madeira and the Canary Islands. First Choice became part of TUI Travel plc. As a result, First Choice and Thomsonfly operated as one from 1 May 2008.

Hispania
This Spanish airline was a regular visitor to the airport until it ceased operations.

Inter European Airways
The airline was formed in 1986 by the Asprou family, owners of the Aspro Travel Group, based at Cardiff. During 1991, Aspro Travel made its northern headquarters at the airport and the company's own airline, Inter European Airways, with at least one Boeing 737-300srs was permanently based at the airport. In November 1993 the travel company and the airline were taken over by Airtours.

JAT Yugoslavia Airlines
The state-owned airline operated flights to Yugoslavia.

Middle East Airlines
Their aircraft were occasionally subleased by other companies.

Monarch Airlines
Formed in 1967 and based at Luton. Up to 1987, Monarch aircraft were often seen at the airport on charter flights operated by Cosmos Travel.

Oasis Airlines International
This Spanish airline only operated IT flights during the 1988/89 season.

Odyssey International
Operated flights to Canada during the summer of 1989.

Spanair
This Spanish airline first appeared at LBA during the summer of 1989 on holiday flights to Tenerife. The airline ownership has since changed but it still operates IT charters to the Spanish mainland and Balearic Islands.

Shaheen Air
Operated a direct link with Pakistan in the Summer of 2007.

Thomas Cook Airlines
The airlines began as JMC Airlines on 1 November 1999 with the merger of Flying Colours Airlines and Caledonian Airways. Re-naming and re-branding took place on 31 March 2003. MyTravel fleet and organisation were incorporated together on 30 March 2008 to form the present airline. The carrier in its various guises has operated IT charter flights from LBA.

Worldways Canada
Operated DC8s and Tristars to Canada during 1987.

Other charter operators include Azzurra Air, British Jet, Futura International, Hemus Air, Iberworld, MyTravel Airways, Pegasus Airlines, Sun Express, Transavia and VLM.